IMAGES
of America

JAPANESE AMERICANS IN SAN DIEGO

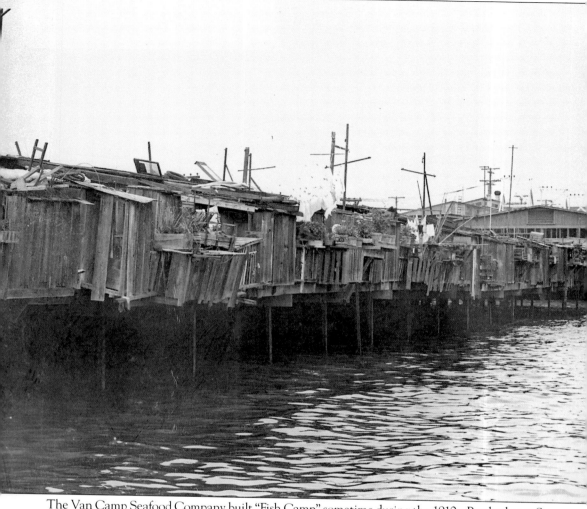

The Van Camp Seafood Company built "Fish Camp" sometime during the 1910s. Perched over San Diego Bay, with sparse living conditions, including outhouses that emptied directly into the bay, Fish Camp (pictured here in 1931) was hazardous for small children, who were in danger of falling into the water under their homes. (Japanese American Historical Society of San Diego.)

ON THE COVER: In this 1926 photograph, Tokichi Namiki, a retired fisherman, supervised young Japanese American children who lived at Fish Camp. Fish Camp housed Japanese American fishing families up until the late 1930s. Fathers worked on tuna boats while their wives found part-time work in the fish cannery. (Japanese American Historical Society of San Diego.)

IMAGES
of America

JAPANESE AMERICANS
IN SAN DIEGO

Susan Hasegawa for the
Japanese American Historical Society of San Diego

ARCADIA
PUBLISHING

Published by Arcadia Publishing
Charleston, South Carolina

Printed in the United States of America

Library of Congress Control Number: 2008928309

For all general information, please contact Arcadia Publishing:
Telephone 843-853-2070
Fax 843-853-0044
E-mail sales@arcadiapublishing.com
For customer service and orders:
Toll-Free 1-888-313-2665

Visit us on the Internet at www.arcadiapublishing.com

*In memory of Don Estes, pioneering historian, preservationist,
activist, community leader, mentor, and friend.*

CONTENTS

ACKNOWLEDGMENTS

The archives of the Japanese American Historical Society of San Diego (JAHSSD) contain a treasure trove of photographs, papers, artwork, and artifacts documenting the San Diego Japanese American experience. The images contained in this book are just a sample of the hundreds of images held by the JAHSSD. The late Don Estes started gathering photographs, documents, oral histories, and other artifacts in the 1970s, and his efforts were the foundation of the JAHSSD collection. Don Estes also laid the groundwork for this project with his numerous publications, including the book *South Bay Monogatari* and articles "Before the War" and "Silver Petals Falling."

This pictorial history was made possible by the generous support of the JAHSSD board, its membership, and its donors. Board members Bob Batchelder, Jeanne Elyea, Naomi Himaka, Michio Himaka, Debra Kodama, Gwen Momita, Ben Segawa, and Joyce Teague were important contributors to this project. Volunteer archivist and board member Linda Canada read numerous drafts, assisted with archival photographs, and provided invaluable support throughout every phase of the book. Other former and current JAHSSD board members, including Nancy Cowser, Noriko Inoue, Karen Kawasaki-Williams, Christina Pierson, Jim Yanagihara, Vernon Yoshioka, and Grace Takeuchi, supported this book from its inception. Volunteer Roy Asaki spent hours translating Japanese-language photograph captions.

I am thankful for the generosity of Hisae Batchelder, Pat Goto Takeshita, Carol Hasegawa Estes, Emiko Shintaku Gonzales, Robert Ito, Po and Amy Kaneyuki, Sumi Kastelic, Mits Kawamoto, Bobby Koga, Hisako Imamura Koike, Hiomi and Marie Nakamura, Sam and Pauline Nakamura, Taka Sawasaki, Takeo Sugimoto, Robert Shimamoto, Bill Teague, Bert Tanaka Jr., Mitsue Tanaka, Motoo Tsuneyoshi, Frank Wada, Robert Wada, and Elizabeth Kikuchi Yamada for sharing their stories, mementos, and photographs.

City College and the San Diego Community College District provided important support to this project. I am also grateful to Charles Kovach for his editorial assistance. Lastly, I am deeply appreciative of the loving support of my husband, Bruce Sherman, and my parents, Harry and Nita Hasegawa of Hana, Hawaii. For more information on the San Diego Japanese American experience, visit the JAHSSD Web site at www.jahssd.org.

INTRODUCTION

In early 1941, the intersection of Fifth and Island Avenues in downtown San Diego teemed with *Nikkei* (Japanese Americans and other persons of Japanese descent living outside Japan) businesses and shoppers. Hungry fishermen ate a meal at the Obayashi-run Sun Café or the little diner run by the Takemotos serving chili and *gohan* (rice). On any given weekend, Nikkei farm families replenished their food supplies from Nippon Shokai, a general merchandise and Japanese food store. Farm children looked forward to the weekly trips into town for cinnamon balls and other treats. *Issei* (first-generation immigrants from Japan) men gathered at the Takahashi pool hall to catch up on the latest community news.

This intersection was the center of the Japanese American business district. Within a two-block radius, there were more than 35 Nikkei-owned businesses, including retail outlets, American-style cafés, Japanese restaurants, pool halls, hotels, and liquor stores. Interspersed with these were Chinese restaurants and laundries, Caucasian-owned businesses, including two secondhand clothing stores and liquor stores, and several Filipino-managed shops. Nonetheless, the Fifth and Island area was commonly known as the beating heart of the Nikkei business district.

The Nikkei community in San Diego goes back to the 1880s, with Issei bachelors who possessed, as a daughter of an immigrant wrote, "an inward spirit of adventure and undaunting faith in the unknown." As they initially worked on railroad crews and as migrant field laborers, the first decades of the 20th century found Issei bachelors settling down as farmers, businessmen, and fisherman. In spite of Alien Land Laws, which prevented Issei ownership of land and restricted leasing rights, Issei started truck farms in rural areas of Chula Vista, Del Mar, Oceanside, Lemon Grove, El Cajon, Pacific Beach, Tijuana River Valley, and Mission Valley. Wanting to plant roots in their adopted country, many bachelors found spouses through a go-between in Japan and the exchange of photographs known as the "picture bride" system. Pioneering Issei women worked alongside their husbands on the farm or in the family enterprise and raised *Nisei* (American-born children of Issei or second generation) children. Issei parents were prohibited from becoming naturalized U.S. citizens but believed the Nisei generation would bridge the gap between mainstream American culture and Japanese immigrants.

Nisei were American citizens by birth and grew up integrating Japanese cultural traditions with a typical American worldview. As many Nisei came of age during the Great Depression, they formed their own clubs and social circles. Nisei started *Seinen-Kai* (a student club) at local high schools, and young adults formed a San Diego chapter of the Japanese American Citizens League (JACL). Many Nisei shared May Sakamoto's viewpoint, expressed in an award-winning essay describing Americanism as a "deep loyalty and love of country in our hearts, not only because we are American citizens, but because we are attached to American ideals and government."

By the eve of World War II, the San Diego Nikkei community had established several Christian churches and a Buddhist temple, and had organized numerous prefectural organizations and farming cooperatives. Social life revolved around community picnics, religious activities, and the Fifth and Island downtown business district; however, by mid-1942, all persons of Japanese

ancestry were removed from not just the county of San Diego, but from the entire West Coast. In the wake of the Japanese attack on Pearl Harbor and the United States' entrance into World War II, Nikkei on the West Coast were branded as possible spies and saboteurs. The backlash after Pearl Harbor shattered the Nikkei business district and changed the lives of the approximately 2,000 people of Japanese ancestry living in the county.

U.S. military orders instructed all San Diegans of Japanese ancestry to report to the Santa Fe Railroad Depot on April 8, 1942. Evacuees could take only what they could carry. Businessmen, farmers, and fishermen lost everything. Initially evacuated to the Santa Anita Race Track for several months, eventually most San Diegans were incarcerated in the Arizona desert in a hastily built "relocation center" called Poston. Stripped of civil liberties, Nikkei persevered through the difficult period they commonly call "camp."

With the end of World War II and the removal of evacuation restrictions, Nikkei returned to San Diego after an exile lasting more than three years. Community leaders restarted religious institutions, and families scrambled to find new homes and jobs. Starting over was not easy, but religious institutions actually increased in numbers with the coming of the postwar baby boom. While many Issei entrepreneurs never recovered from internment, college-educated Nisei capitalized on employment opportunities in the growing aerospace industry and the civil service. Furthermore, with the Issei generation approaching their twilight years, Nisei took an active leadership role in preserving a distinct Japanese American community.

With high rates of interracial marriage and numerous *hapa* (interracial), *Yonsei* (fourth-generation), and *Gosei* (fifth-generation) children, the San Diego Nikkei community faces new challenges in the 21st century. Many college-educated *Sansei* (third generation) left the farm and family business to become engineers, physicians, and accountants. Religious institutions and secular community organizations remain an important source of community identity; however, each faces its own challenge in the ongoing evolution of San Diego's Nikkei community.

The images in *Japanese Americans in San Diego* come from the archive of the Japanese American Historical Society of San Diego (JAHSSD), its members, and its donors. Established in 1992, JAHSSD is committed to preserving the Nikkei experience in San Diego County through educational programs and projects to increase awareness of Nikkei contributions to the region.

One

ISSEI PIONEERS

Japanese settlement in San Diego occurred within the context of international emigration from Asia in the late 19th century. Most Japanese came to the United States of America as sojourners who intended to work abroad for a couple of years, save money, and return to Japan. Most early immigrants were single men under 25 years of age. Many had dreams of returning to Japan with enough money to buy property and marry well. As the years passed, many Issei saw a future in remaining in the United States.

Issei bachelors wanting to start a family found brides through the picture bride system. A few returned to Japan for arranged marriages. Once settled in San Diego, Issei families had to familiarize themselves with American cultural norms. There were confusing periods, as one Issei who attended high school in Oceanside recalls: "Sometime we didn't know about holidays. We went to school to find no one there, and wondered what was happening."

In San Diego, Issei farmers found fertile land to develop successful truck farming businesses. The number of Japanese farmers in the county steadily increased from 32 in 1905 to more than 100 by 1940. As Issei farmers proliferated and became more successful, they formed collective associations to overcome racial barriers, expanding beyond simple production. In 1918, since Caucasian vegetable brokers refused to ship their produce, four Issei farmers formed the Vegetable Growers Union. Meanwhile, small businesses—laundries, restaurants, retail groceries, pool halls, and barbershops—were clustered near the intersection of Fifth and Island Avenues in the southern section of downtown San Diego.

Because Japanese immigrants generally did not have access to capital from American banks, they often acquired capital from their own communities. Issei farmers and businessmen often participated in a *tanomoshi*, in which a group of men contributed to a monthly pool of capital. Participants took turns using the capital gathered in different economic endeavors. This pattern of ethnic-specific mutual aid was replicated in farming cooperatives and other business ventures.

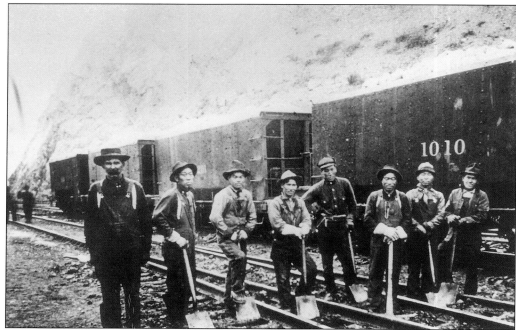

The first documented Japanese immigrants came to San Diego to work on the railroads in the 1880s. Migrant Japanese laborers also worked the fields in Chula Vista, Lemon Grove, and La Mesa.

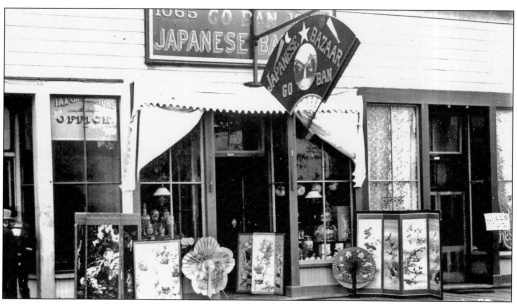

In 1887, Azumagasaki Kikumatsu opened the Go Ban, the first Japanese-owned retail business in San Diego. Located at 1065 Fifth Avenue, the Go Ban sold Japanese curios and art items.

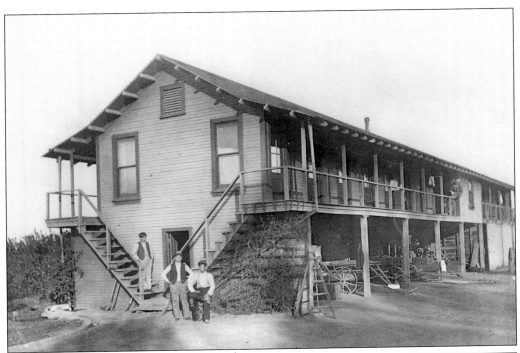

Early Issei bachelors found work as agricultural laborers, as in this 1912 image (above). The Shimokawa Camp barracks in the Bonita Valley housed Japanese labor gangs and were used until the late 1920s. A labor contractor, bilingual in Japanese and English, ran the operation and interfaced with local farmers to supply seasonal workers.

Issei laborers are dressed in their nicest clothes for a c. 1909 Sunday morning outing. The Kiyohara Camp housed Issei field laborers, who were paid an average of 5¢ an hour for a 10-hour work day, less labor contractor deductions and expenses.

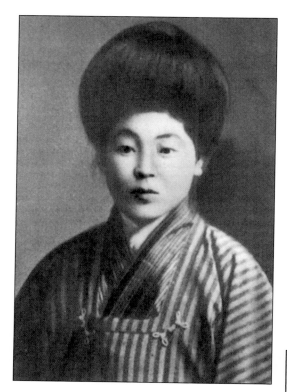

In 1914, a go-between matched Nobuye Kusui (pictured)—a hospital nurse from Wakayama, Japan—with Takejiro Kodama, an Issei farmer in California. After a marriage ceremony by proxy in Japan, they met for the first time at their in-person exchange of vows at the Angel Island Immigration Station in San Francisco. The Kodama family farmed in Imperial Valley for decades. Their grandson, Kenny Kodama, settled in Chula Vista.

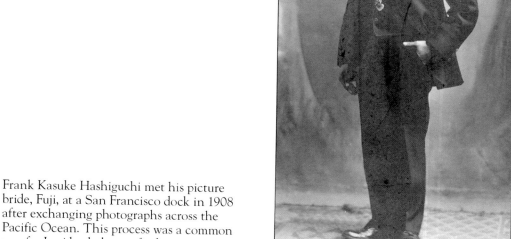

Frank Kasuke Hashiguchi met his picture bride, Fuji, at a San Francisco dock in 1908 after exchanging photographs across the Pacific Ocean. This process was a common way for Issei bachelors to find spouses.

Although many Issei bachelors found spouses through the picture bride system, not all nuptials were the result of photographs. Shigeru (right) and Yuki (below) Masumoto were married in Japan before immigrating to the United States in the second decade of the 20th century. National City was their final destination, where they settled in 1936 to start the S&M Nursery.

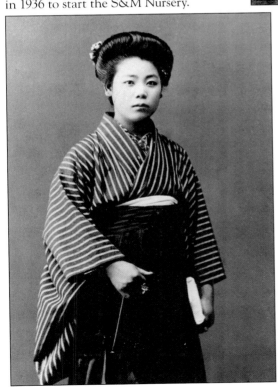

Continuing cultural traditions from the home country, Issei parents often dressed their children in traditional Japanese clothing for formal photographs to send to far-off relatives in Japan. Katherine Tasaki Segawa posed for this formal photograph in the 1930s.

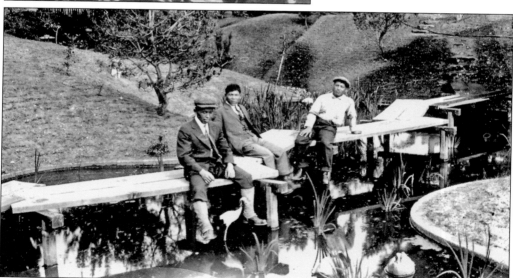

Wealthy businessman Joseph Sefton employed Issei landscapers to build this Japanese-style garden at his Point Loma home around 1919. Entrepreneurial Issei like Frank Kasuke Hashiguchi (far right) worked a variety of jobs, including landscape gardener and farm cooperative driver.

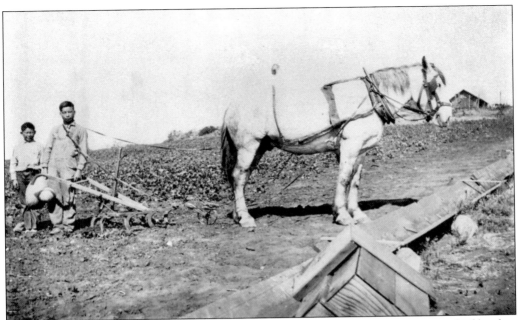

Starting out as farm laborers, Issei bachelors dreamed of acquiring their own parcel of land to farm and of starting a family. Issei pioneers started small family farms in rural San Diego County. Mission Valley (pictured) proved popular for a handful of farmers planting winter celery and other row crops. Other Issei farmers settled in El Cajon, Chula Vista, National City, and Otay Mesa.

The Hosaka and Kiya families enjoyed a picnic in front of the first Spanish mission in California, Mission San Diego de Alcala, between 1916 and 1919. Minetaro Hosaka (seated center), holding his daughter, Virginia, farmed the rich soil below the mission. In addition to commercial crops of celery, he also planted Japanese vegetables like *daikon* (horseradish) and *gobo* (edible burdock) for the family pantry.

Formed in 1906 but incorporated in 1913, the San Diego Nihonjinkai (Japanese Association) was the main voice of Issei in San Diego. Officers gathered at its downtown office in 1926 for this image. The organization spearheaded Japanese community involvement in the 1915 Panama-California Exposition in Balboa Park.

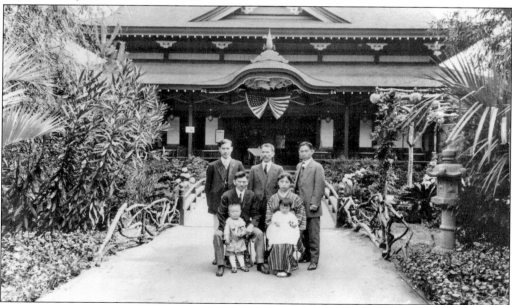

Built in Japan and shipped to San Diego for the 1915 exposition, the teahouse building was reassembled in traditional Japanese style without the use of nails. The Asakawa family managed the teahouse after the exposition. From left to right are (first row) Motoharu and Harue Asakawa; (second row) Hachisaku and Osamu Asakawa; (third row) Kakuo Henry Yoshimine, Sukeharu Yato, and Sukazu Yato.

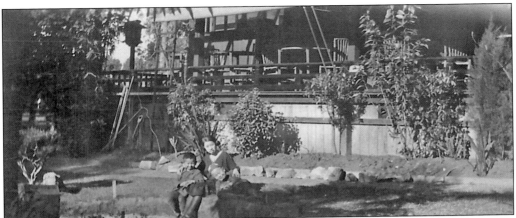

Osamu Asakawa (pictured with her children) managed the popular Balboa Park Japanese Tea House and Garden, where Nikkei families celebrated parties and birthdays. In the 1920s, her husband, Hachisaku, farmed in Mission Valley and later formed the San Diego Fertilizer Company with his partner, Yutaka Fujii.

Yoshigoro "Yosh" Mamiya (sitting in the car) served 16 years in the U.S. Navy as a mess man before settling down in San Diego. He married picture bride Tami Nagasawa (standing, far left), and together they ran a barbershop in downtown San Diego. Balboa Park was a popular site for Nikkei families to take formal family photographs.

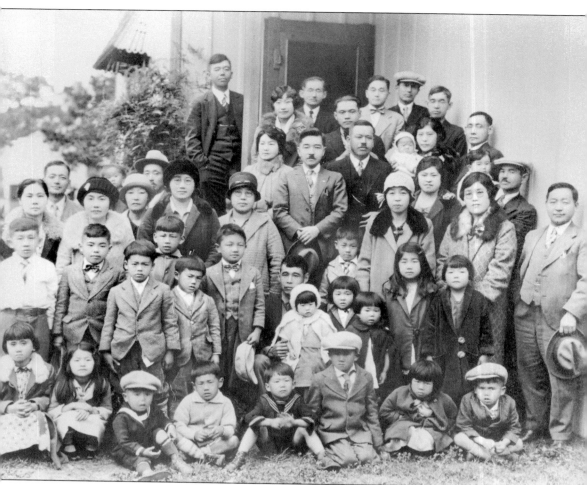

Many Issei who settled in Coronado emigrated from Kagoshima. Issei found work at the Hotel del Coronado and as gardeners in the surrounding Coronado neighborhoods. By 1940, the Japanese Consulate reported 16 Nikkei households living on the island. Taken at the Nagano home in 1928, the photograph features the Fukushima, Hashima, Koba, Takeshita, Matsumoto, Mayeda, Nagano, Sato, Shirai, Tateyama, and Tsuneyoshi families.

Two

FAMILY ENTERPRISES

Nikkei enterprises were clustered in three industries: farming, small businesses, and fishing. Farming was the economic engine of the Nikkei community. Issei operated truck farms up and down the coast and in the inland areas of El Cajon, Spring Valley, and Mission Valley. Issei retail businesses like Nippon Shokai and Kawasaki Grocery catered to the Nikkei community with Japanese food items and imported Japanese products. Issei fishermen were able to capitalize on the growing popularity of canned tuna and sardines, and introduced new equipment and techniques to the local fishing industry.

By 1940, Issei farms across the county ranged in size from several acres to a 100-acre flower farm in Pacific Beach. Farmers cultivated fruits and vegetables, including tomatoes, cucumbers, and celery. With rich soil and an accessible water supply, Chula Vista was preferred by Issei farmers for their farms. They pioneered the planting of winter celery in Chula Vista during the early decades of the 20th century, and it became a profitable crop for both Caucasian and Japanese farmers.

Issei innovations and techniques were major contributions to the San Diego fishing industry. Japanese began fishing in San Diego in the early 1900s. Using techniques learned in Japan, Issei introduced the bamboo pole, the barbless hook, and new chumming methods to attract fish. At the same time, advances in the cooking and canning of tuna spurred the mass production and consumption of this "chicken of the sea." In 1911, the Pacific Tuna Canning Company opened a cannery in San Diego and the city became a leading producer of tuna for the U.S. market. This increased the demand for skilled fishermen, and in 1917, about half of the crews in the 397 cannery-owned boats in San Diego were staffed by Japanese. In the following year, membership in the San Diego Japanese Fishermen's Union topped 200. Even though the Great Depression led to a steady decline in the number of fishermen, Nikkei improvements in the fishing industry had a lasting impact.

By the 1920s, Chula Vista was known as the "Celery Capital" of the United States, and Issei farmers played a major role. Fukutaro Muraoka (left) and his son, Saburo Muraoka (below), were pioneering farmers in Chula Vista. Arriving in San Diego in 1910 as an itinerant laborer, Fukutaro introduced winter celery to Chula Vista. He summoned his son, Saburo, from Japan to help with the farm. Both were credited with introducing new planting techniques and with the use of cucumber tents. Cucumber seedlings grew faster when planted on an incline and shielded with paper tents commonly called "hot caps."

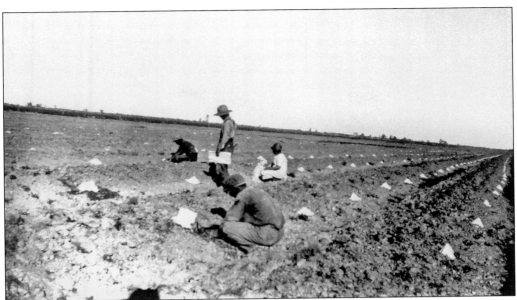

Hot caps protected watermelon seedlings in a local field around the 1930s. Farm families' children were often enlisted to place hot caps on all seedlings, and this technique was used into the 1950s, when farmers starting using plastic sheeting.

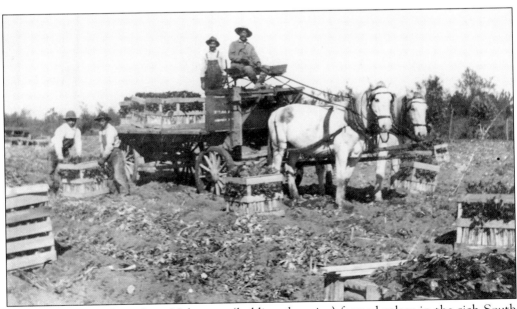

Pictured in 1920, Torazaburo Nakagawa (holding the reins) farmed celery in the rich South Bay soil.

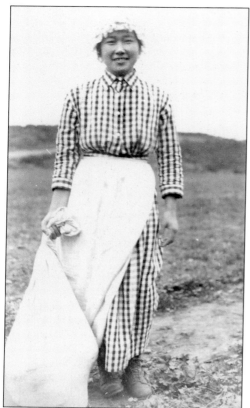

Farming was a family affair. Kajiro Oyama recalls, "Each day my wife would pack the tomatoes. She would pack between 800 to 900 boxes a day. . . . My daughters sorted them, and my two sons brought the tomatoes that had been picked by the workers to the packing shed. The family required everyone's help to survive." Sado Tsuneyoshi, pictured in the 1920s, worked in the family's rented fields.

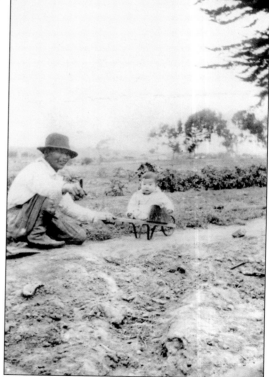

Pacific Beach was home to scattered Nikkei farms growing row crops and flowers. In 1926, Yataro Yamaguchi plays with his daughter, Edith Yamaguchi Suzuki, in a field.

Issei farmers introduced new techniques for growing crops and are credited with using poles to support tomato vines. Tomatoes grown in this manner were commonly called "pole tomatoes."

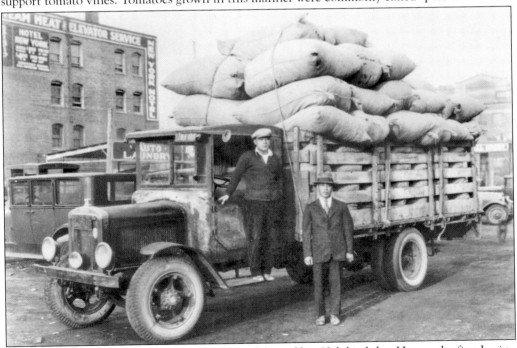

In 1933, Kiso Yasukochi (pictured in the suit) celebrated his 60th birthday. He was the first Issei to build a commercial pepper dehydrator and acquired the moniker the "Pepper King" for his success in chili pepper production in Garden Grove. Cultivating 42 acres of chili peppers in San Marcos, he moved to San Diego County to join his second son, Taisuke, who was farming in Bonsall.

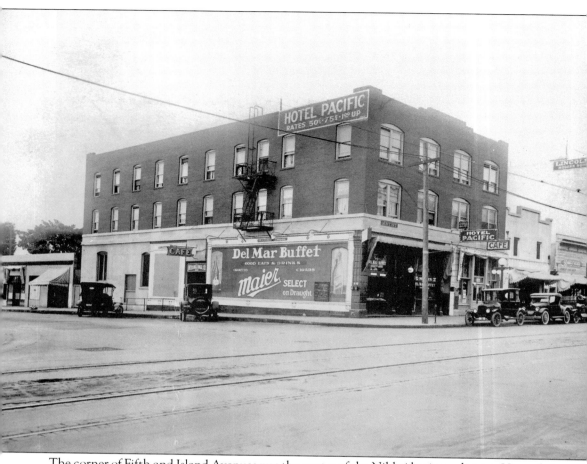

The corner of Fifth and Island Avenues was the center of the Nikkei business district. Hironaka's Barber and Bath was located in the far left of the photograph, under the open awning. The Hotel Pacific was managed by the Tsumagari family, and farther to the right in the photograph were Iwata Billiards and Kawasaki Grocery. Downtown resident Masaaki Hironaka remembers that "the majority of the Japanese population was out in the country. When I say 'in the country,' in those days, anything beyond 30th Street was in the country. The streetcar used to only go to 39th and Ocean View, or like Euclid and University [Streets]. Those people in the country were mainly farmers, and we saw them maybe once a week when they came to market [shopping in downtown], or they came to town to re-provision their homes."

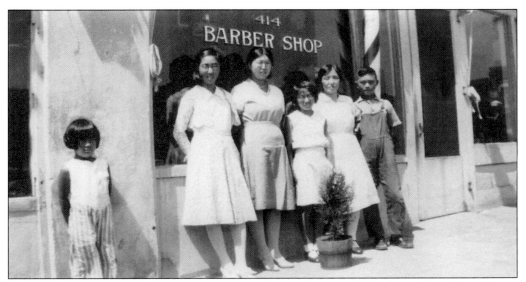

In 1940, Ichi Hironaka's customers could get a haircut, shave, and bath for 50¢. Located near the intersections of Fifth and Island Avenues, the establishment was one of three women-owned barbershops. Like other Nikkei business owners in the area, Hironaka and her family lived in the back part of the shop. From left to right are Teru Watanabe, Teruye Hironaka, Sumako Hironaka, Tsuneko Hironaka, Ichi Hironaka, and Masaaki Hironaka.

In the 1930s, the Himaka family opened a *tofuya* (tofu store) in the Fifth and Island business district, selling Japanese food items like tofu, *konyaku*, and *senbei*. Michio Himaka remembers going with his father to deliver tofu to Nikkei families in National City. The Himaka family member are, from left to right, Kazuye (adult in back), Mizue (child in front), Suma, Osao, Michio, Chosuke, Emi, and Tetsuo.

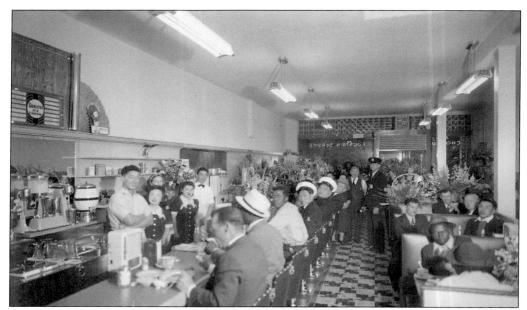

The Sun Café, founded by Uichiro Obayashi (standing next to the police officer), was originally a shooting gallery. On cold nights, Obayashi often served soup to clients. The popularity of his dishes led him to open the Sun Café in the 1920s. Uichiro's adult children, (beginning far left, from left to right) Al, Florence, Hanako, and George, all worked in the family enterprise. The photograph commemorates the business being remodeled in early 1941.

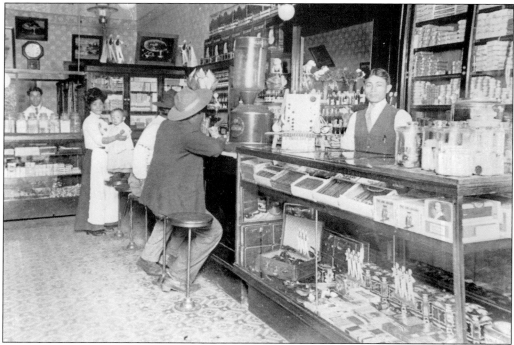

With Prohibition making it impossible to sell alcoholic beverages, Kikuji Kawamoto instead opened a confectionery and soda fountain shop in the early 1920s.

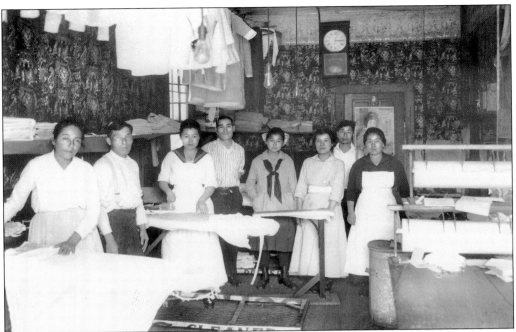

Chozol Watanabe and his wife, Masa, (the couple at far right) opened the Yokohama Laundry in the 1920s, and the operation employed six workers. Like many immigrant groups before them, Issei started in labor-intensive services like laundries and barbershops.

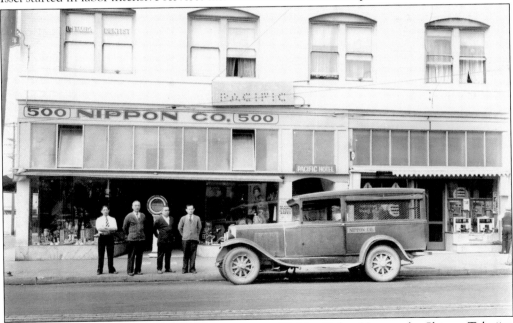

Pictured from left to right, Issei business partners Kichita Kubo, Hyonosuke Shima, Tokujiro Suzuki, and Shigenobu Imamura utilized a *tanomoshi* (a private method of acquiring capital, see page 9) to start Nippon Shokai in the 1930s. The largest Japanese retailer in San Diego, Nippon Shokai sold a variety of Japanese foods and products.

Hiomi Nakamura and Phil Acker sit outside the La Jolla Café around the 1920s. Hiomi's father, Naojiro Nakamura, opened the restaurant in the 1920s after working as a chef for downtown San Diego's University Club and also for businessman John D. Spreckels.

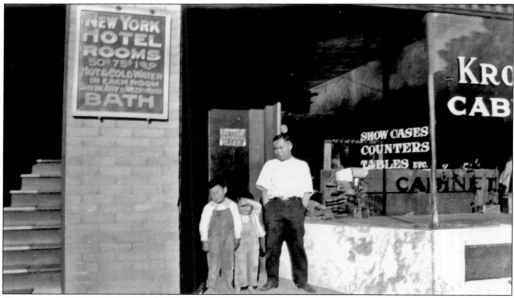

Kumigaru Shimamoto and his wife, Tori, managed the New York Hotel on Fourth Avenue. Lodgers included farm workers and restaurant service workers, seen here around 1930. During the Depression, Nikkei families managed numerous hotels in the Fifth and Island Avenues area. The parents managed and cleaned the rooms, and provided handyman services. The street was the playground for children growing up there.

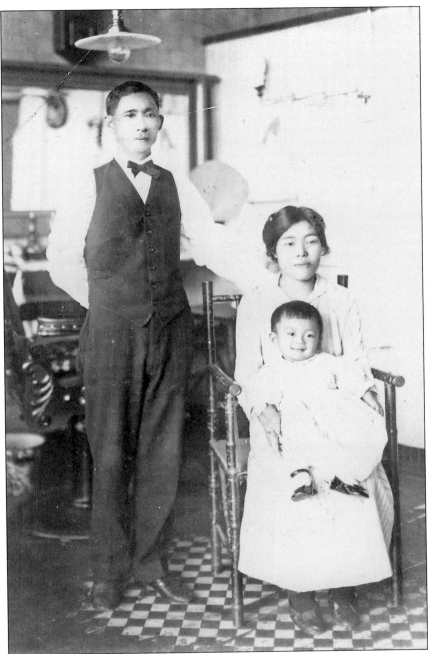

Yoshio "Buddy" Mamiya (the young child) followed his parents, Tami (seated) and Yoshigoro (standing), into the barbershop business (pictured *c.* 1910). Mamiya's Barbershop and Bath became a gathering place for local Nikkei. Buddy remembers, "I had a pretty good sized barbershop with a big kitchen in the back, and the fisherman used to bring the tuna by the round. They never used to put it in the brine, they used to put it in the refrigerator so the meat wouldn't get black. We used to have the fish there, and the farmers would bring their vegetables, and we had an exchange going there. The farmer would take the fish and leave the vegetables."

By the 1930s, Issei entrepreneurs spread beyond the confines of Fifth and Island Avenues. In 1936, Eddie Yamashita owned a fleet of automobiles for his San Diego Wholesale Florist, located at 1344 E Street.

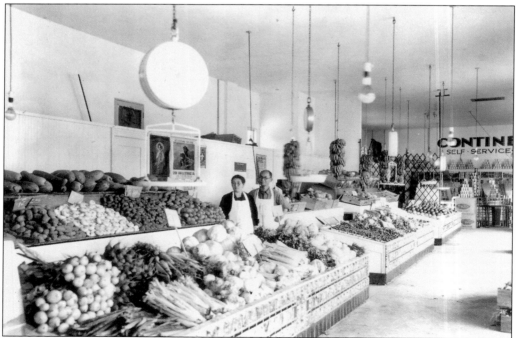

The Ono family, pictured here in the late 1930s, opened a produce store on Twenty-fifth and Broadway Streets in Golden Hill.

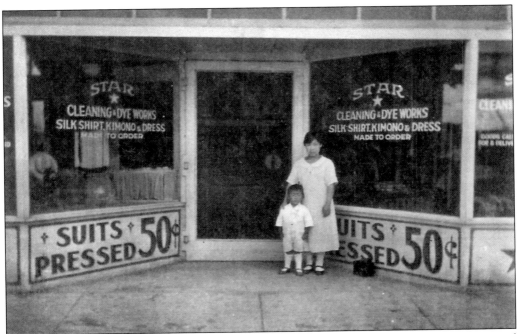

George Watanabe and his wife, Kesaye, (pictured around 1926) managed the Star Cleaning and Dye Works. Their son Arnold, also pictured, grew up hanging out at the shop.

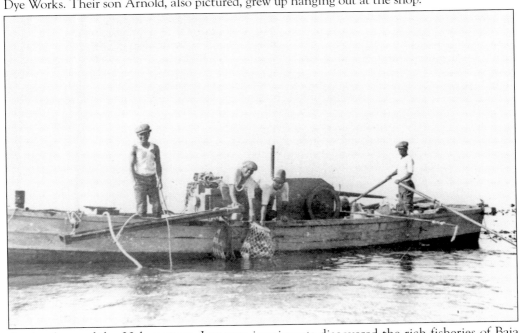

At the dawn of the 20th century, Japanese immigrants discovered the rich fisheries of Baja California, and fisherman Jirohichi Kikuchi relocated his three-boat fleet from San Pedro to San Diego Bay, the closest harbor. Kikuchi also gathered the much-prized abalone for export to Japan. While a 1924 crew manned the air hoses and nets, helmeted divers gathered the abalone shells from the ocean floor.

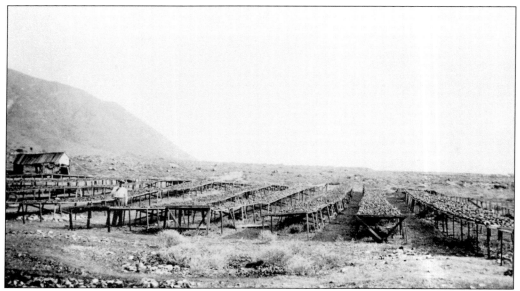

In 1912, Japanese entrepreneur Masaharu Kondo secured a fishing concession in Turtle Bay in Baja California but based his operations in San Diego. Harvesting abalone was a major component of the company. Japanese fishermen dried abalone on raised racks, out of reach of hungry animals. After many years of effort, Kondo completed a wharf and cannery at the site in 1929.

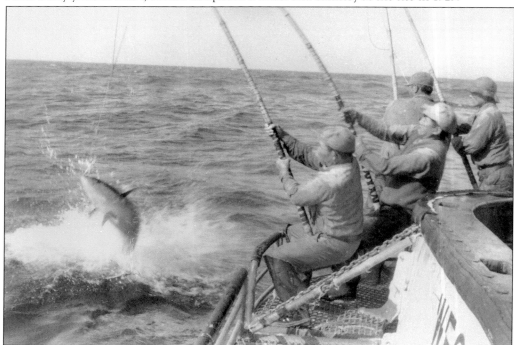

Issei fishermen brought sturdy bamboo pole fishing equipment from Japan to contribute to the developing tuna industry in San Diego. Two to four men worked the long flexible poles. Multiple poles were attached to a single lure with a barbless hook or "squid." Fishermen using this method could hook and land tuna weighing more than 200 pounds with relative ease.

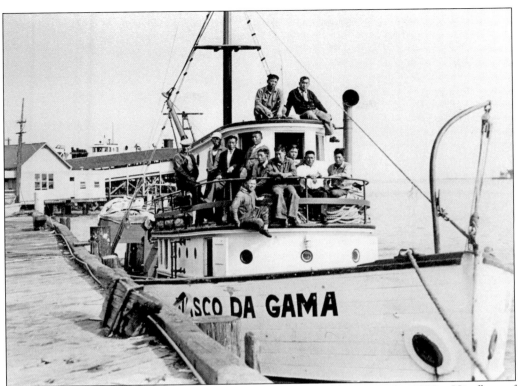

Masaharu Kondo was the first to utilize fully refrigerated boats in the 1920s. His fleet of boats, including the *Vasco da Gama* (pictured), plied the ocean from Mexico to Panama in search of tuna.

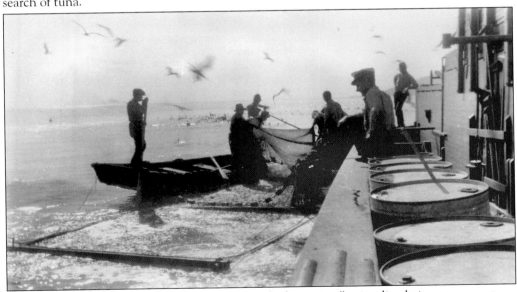

Issei fishermen also introduced the technique of "chumming," using live bait to create a tuna feeding frenzy. The *White Cloud* loads live bait before heading out to deeper waters in 1933. By the 1920s, Japanese fishermen comprised 50 percent of fishing crews based in San Diego.

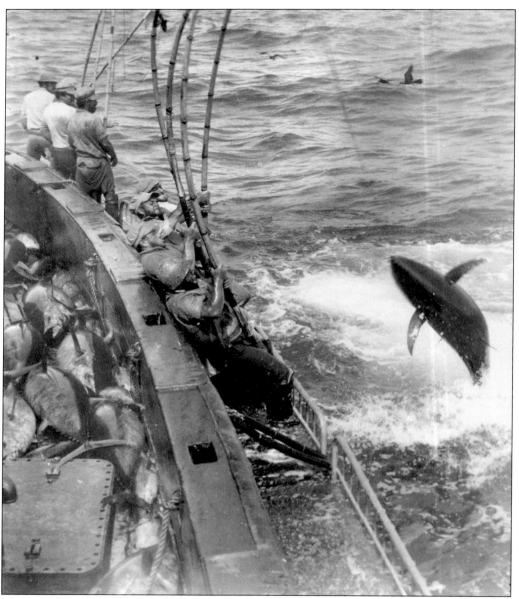

Motosuke Tsuida, captain of the *White Cloud*, states, "Using the pole, the Japanese fishermen could catch the fish fast. Our men fished with a certain rhythm, and the fish would come off the hook in mid-air. From a distance the tuna looked like silver petals falling from a tree." Fishermen used a four-man pool to hook this tuna.

World War I and voluntary rationing during "meatless" days helped spur the demand for canned tuna. Issei fishermen partnered with fish canneries in a reciprocal economic relationship. A fishing boat unloads a catch at the Van Camp cannery in 1939.

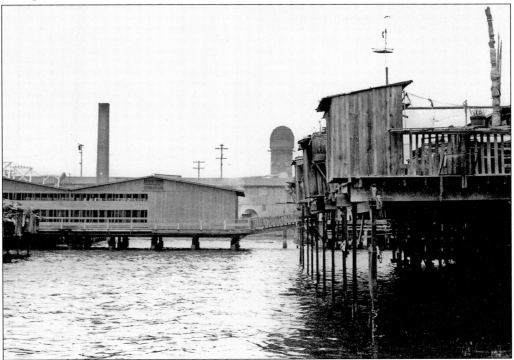

Fish Camp (far right, pictured in the 1930s) was located on two piers jutting into San Diego Bay. It was home to scores of Nikkei fishing families. Fish Camp was within close proximity to both the boat docks and the Van Camp fish cannery, where many Nikkei women worked.

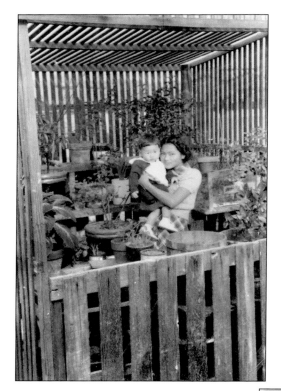

Fish Camp resident Sakiko Okamoto Kada plays with toddler Robert Noda while tending her father's greenhouse around 1939. The cannery provided fishermen free housing and often loaned fishermen funds for boats and living expenses during the off-season.

Kiyo Tsuida Uda (pictured in the 1930s) lived in a second fish camp nicknamed "Hokkaido," after the northernmost island in Japan because this camp was near the northernmost of the local canneries. Nikkei fisherman and their families lived in the cannery-sponsored housing. The Tsuida family was involved in the fishing industry both before and after the war.

Three

BUILDING A NIKKEI COMMUNITY

Continuing an age-old process, every year, Nikkei families gather before year's end to make a traditional Japanese food called *mochi*. Pounding mochi, or *mochitsuki*, is a community affair, with everyone helping to create mochi for the New Year's celebrations. Preparing mochi rice and pounding the mochi dough was a long and arduous task. The process of making mochi takes community cohesion and builds social bonds. Forming Nikkei institutions, likewise, took many hands and major commitments from community members.

By 1940, the Nikkei community had established several social and economic organizations for mutual aid and support. In San Diego and other West Coast cities, Issei from the same region in Japan often formed prefectural associations, or *kenjinkai*. These associations not only planned social activities, including picnics and other celebrations, but they also provided vocational training, networking, and employment opportunities to their members. A significant portion of the Issei in San Diego came from the Hiroshima, Wakayama, and Kagoshima prefectures, and they all formed associations with offices in the Nikkei business district.

While prefectural associations recognized a person's place of origin in Japan, religious organizations developed on the basis of shared beliefs that cut across regional lines. These organizations included a Buddhist temple, a small Shinto sect, and two Protestant churches. Before 1940, the three largest religious organizations became quite prosperous, moved from rented buildings, and bought property in or near Nikkei community members. The Buddhist Temple of San Diego, the First Japanese Congregational Church (later the Pioneer Ocean View United Church of Christ), and the San Diego Holiness Church (later the Japanese Christian Church) found permanent homes near the highly populated Nikkei areas near downtown and in Logan Heights.

In the 21st century, the three major religious institutions—the Buddhist Temple of San Diego, the Pioneer Ocean View United Church of Christ, and the Japanese Christian Church—have evolved but continue to provide a Nikkei community identity. Families still come together for mochitsuki, but electric rice cookers have replaced wood-burning fires, and machines are used for part of the pounding process.

Shig Ito describes the Otay Valley area in the 1920s: "There was no electricity in our area at the time and the toilet facilities were outhouses. . . . Then there were the joyous occasions when we would take part in a *mochitsuki* [pictured] at the Itos' [Toyokichi Ito] residence, and everyone would participate except us kids, who were too small to pound the *mochiko*."

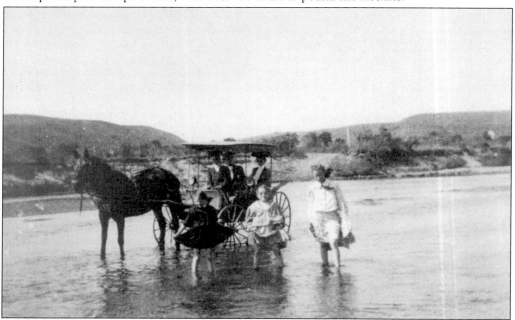

A number of Issei farmers lived below the Lower Otay Dam in 1916. Following a prolonged drought, the area received several days of heavy rains. During preparation for evacuation, the dam broke, and 11 Nikkei died in the flood. The deaths and following burials were the stimulus for Issei leaders to start a Buddhist temple. Here a Nikkei family wades through the floodwaters.

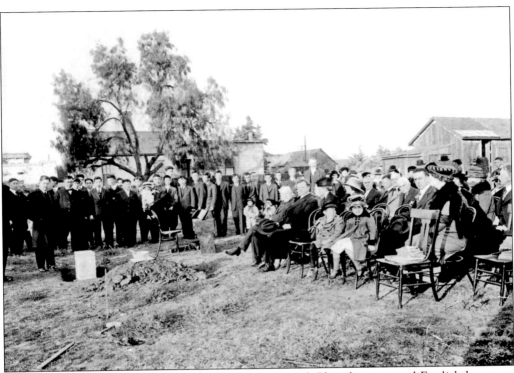

Established in 1907, the First Japanese Congregational Church sponsored English-language lessons at night for local Issei. Originally supported by the First Congregational Church of San Diego, the church grew in numbers and laid the first cornerstone in 1920 for its new building at 431 Thirteenth Street.

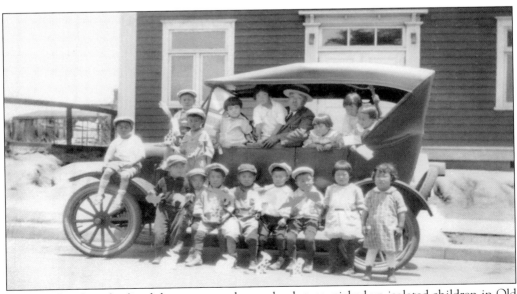

Gizo Kitabatake, who lived downtown and ran a bookstore, picked up isolated children in Old Town, Point Loma, and other areas, and took them to church around the 1920s.

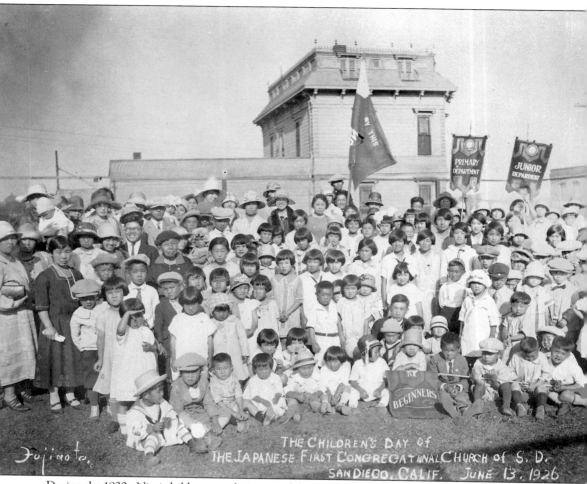

THE CHILDREN'S DAY OF
THE JAPANESE FIRST CONGREGATIONAL CHURCH OF S.D.
SAN DIEGO, CALIF. JUNE 13, 1926

During the 1920s, Nisei children greatly increased the membership of the First Japanese Congregational Church. The congregation grew to include several departments for the young children (shown here in 1926), and a Young People's Society was formed for high school students.

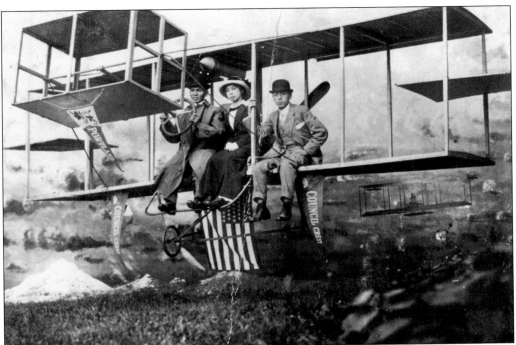

Issei attendees were plentiful at the 1915 Balboa Park exposition. The Asakawas (from left to right, Hachisaku, Osamu, and cousin Gizo) had their photograph taken with this fake airplane as part of the festivities.

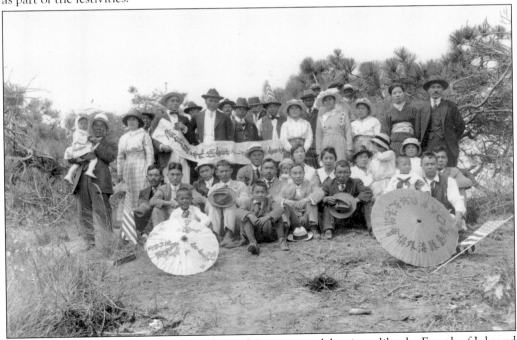

Issei pioneers readily adopted many traditional American celebrations, like the Fourth of July and Christmas. The Hiroshima Kenjinkai held a Fourth of July picnic at Torrey Pines in 1918.

Fish Camp had a large enough population to support three different *mochitsuki* events.

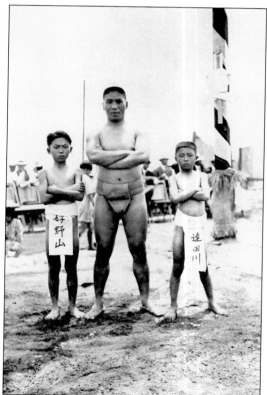

Sumo wrestling matches were held in a downtown vacant lot near Fourth and Island Avenues. Yoshio Mamiya (left) and his brother, Tatsuo (right), wait for their turn in the ring in the 1920s.

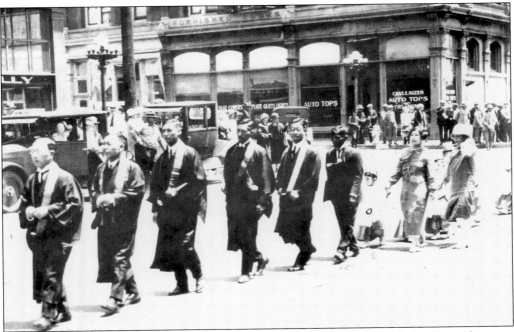

After years of meeting in a local restaurant, temple leaders rented space on Market Street, between Sixth and Fifth Avenues. Pictured in 1926, a parade through downtown San Diego commemorated the dedication of the altar for the first Buddhist temple.

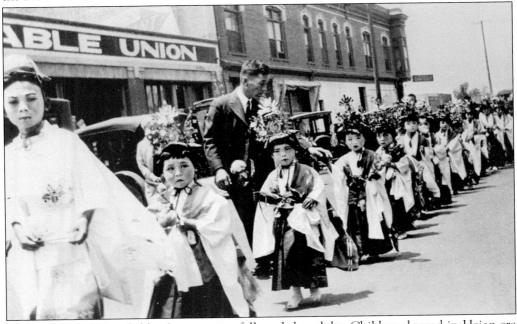

The *Ochigo* or *Chigo* children's procession followed the adults. Children dressed in Heian-era (8th–12th century CE) costumes and carrying lotus leaves as a symbol of purity represented heavenly beings. The white makeup and two black dots between the eyebrows copied Heian court nobility.

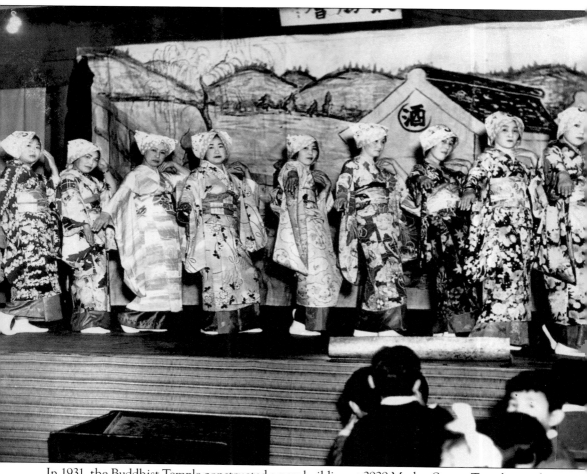

In 1931, the Buddhist Temple constructed a new building at 2929 Market Street. Temple member Yukio Kawamoto remembers, "In the early days, the temple was the social center as well as a religious center for the Japanese community. Japanese movies were shown, local talent put on plays called *Shibai*, talent shows were put on, Japanese martial arts such as kendo and judo were practiced, and ballroom dances were held. Because the temple didn't have a social hall at the time, all the community activities were held right here in this room. Speaking of movies, there was no admission charge, but families were expected to make a donation. Each donor's name and the amount of the donation was written in Japanese on a piece of paper and posted around the hall." Dancers dressed in traditional kimonos perform a folk dance around the 1930s.

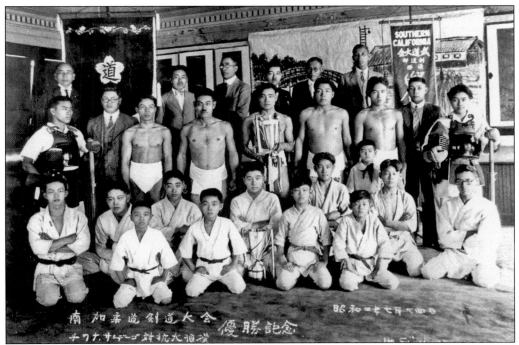

At this 1927 tournament, the Southern California Judo-Kendo Club members posed for a Tijuana–San Diego group photograph.

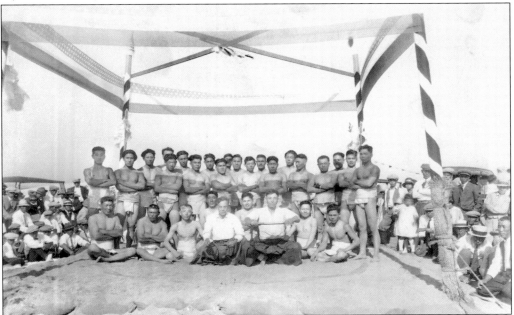

Community members built a sumo ring on the Silver Strand for this tournament in 1929. The athletes' aprons indicate their wrestling name, ending in symbols of strength like river, mountain, and island. Issei leaders paid respect to both their adopted and native country with a Japanese flag and an American flag flying above the ring.

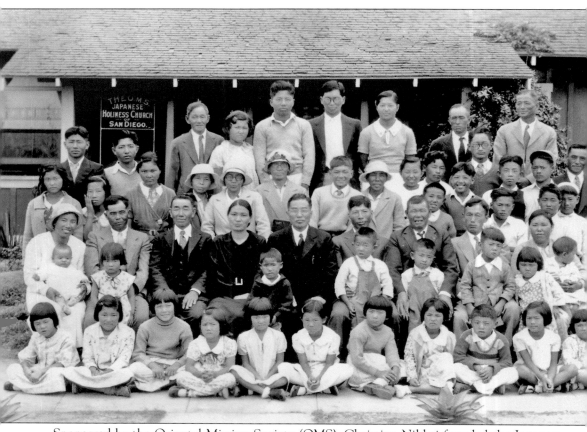

Sponsored by the Oriental Mission Society (OMS), Christian Nikkei founded the Japanese Holiness Church in 1930. The church focused on outreach to Issei farmers.

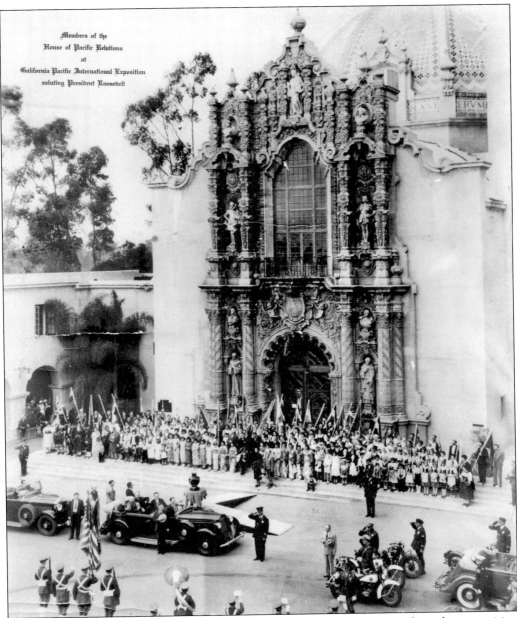

Members of the
House of Pacific Relations
at
California Pacific International Exposition
saluting President Roosevelt

During the Great Depression, San Diego civic and business leaders organized another exposition to attract tourists and boost civic morale. Members of the House of Pacific Relations were present to greet Pres. Franklin Roosevelt at the 1935 California Pacific International Exposition. Nikkei women, dressed in kimonos, were at the forefront of the contingent.

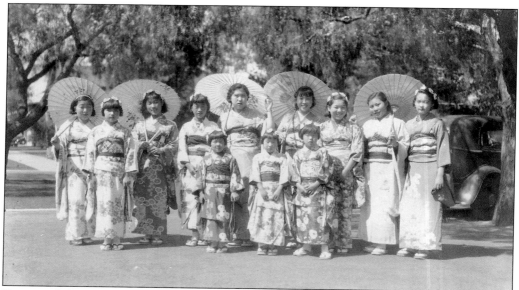

Kimono-clad young women performed a traditional Japanese dance at the Japan Day celebration at the California Pacific International Exposition. Dancers are, from left to right, (first row) ? Miyamoto, Asako Kobayashi, and Michio Sakaguchi Okuma; (second row) Kazumi Minamide Hayashi, Sakiko Okamoto Kada, Kame Kobayashi, unidentified, Tsuru Kobayashi Noda, Yoshiko Nakamura Kuyama, Midori Matsumoto, Yukie Nakamura Hayashi, and Sumako Saito Uda.

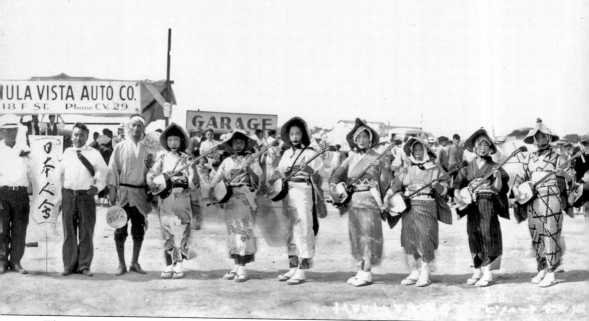

The 1937 San Diego County Coalition picnic sponsored a performer's parade and featured everything from Felix the Cat to traditional *shamisen* (stringed instrument) musicians. The

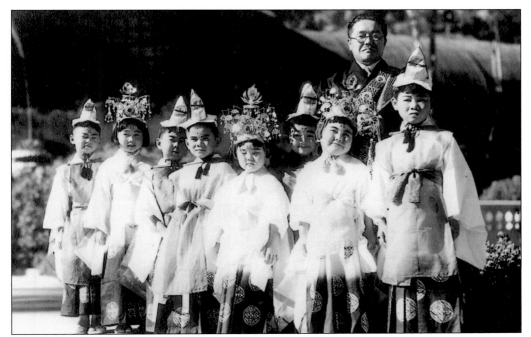
Youngsters from the Buddhist Temple commemorated the auspicious occasion with an Ochigo parade through Balboa Park for the exposition.

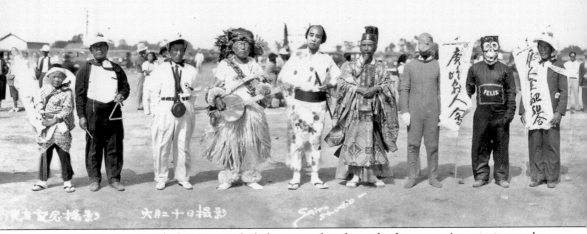
summer celebration in Chula Vista included sponsorship from the Japanese Association and various prefectural organizations.

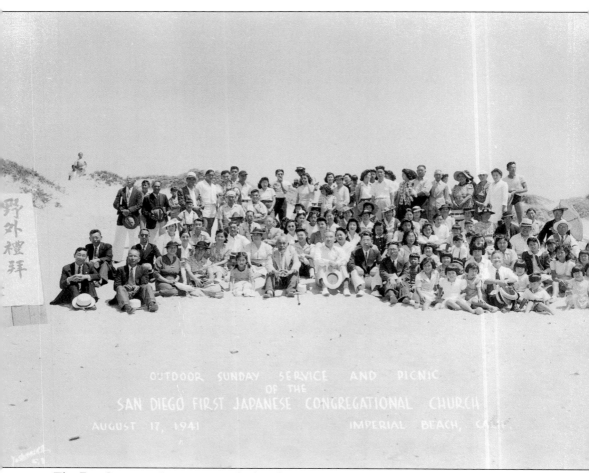

The First Japanese Congregational Church sponsored an outdoor Sunday service and picnic at Imperial Beach in 1941.

Four

GROWING UP NISEI (SECOND GENERATION)

Nisei children grew up in traditional Japanese households, attended Japanese-language schools, and participated in Nikkei community activities; however, Nisei were also involved in many traditional American activities. To support Nisei interests, religious organizations sponsored Boy Scout and Girl Scout troops by the 1930s. In addition to traditional Japanese sports of sumo and *kendo* (Japanese fencing), baseball games became a common fixture at community picnics.

Japanese-language school was a rite of passage for most Nisei children. Children dutifully attended Japanese school for several hours after the normal school day and all day on Saturdays. Yuki Kawamoto recalls, "I was never a very good student. Rather than grade levels, promotion was by book number, Book 1, Book 2, etc. Every time a new teacher came, they tested the class to see where everyone stood, and invariably, I would be knocked down a few books. The highest book number I achieved was Book 12, but when I was finally allowed to quit, I was down to Book 7—some progress, huh." Despite the strict instructors and the loss of free time, many Nisei have fond memories of Japanese school.

Nisei who came of age in the 1930s showed their independence by forming youth-centered organizations. Founded in 1933, the Japanese American Citizens League (JACL), San Diego chapter, encouraged Nisei participation in the American political process and fostered friendships between the Nikkei community and mainstream America. JACL members attended national conferences, conducted voter registrations, and sponsored social activities like dances and picnics.

In addition to the JACL, Nisei youth formed ethnic-specific organizations in the public education system. The Seinen-Kai student club at San Diego High School was a coeducational club promoting friendship "among Japanese American students." Started in 1932, Seinen-Kai sponsored a faculty tea, skating parties, and recreational outings to the beach and mountains. With the JACL and the Seinen-Kai, Nisei youth and young adults were forming social networks, focusing on their priorities, and reflecting on the emerging Japanese American culture.

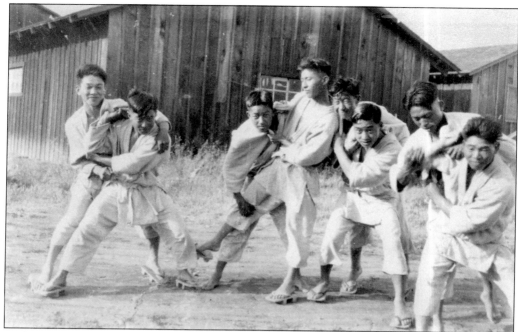

With few amenities for community activities in the early years, teachers held judo classes in the back of a local barn in the 1920s.

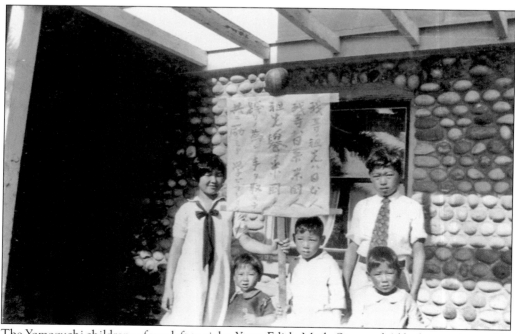

The Yamaguchi children—from left to right, Yone, Edith, Mark, Sam, and Alfred—are pictured in front of their Pacific Beach home on Lamont Street in 1929. The poster reads: "Our ancestors are Japanese. We are Japanese Americans. For the honor of our ancestors and the pride of America, let us hold hands, encourage each other, and study."

From tending the family garden to pounding together packing crates, Nisei children were often enlisted in chores around the farm.

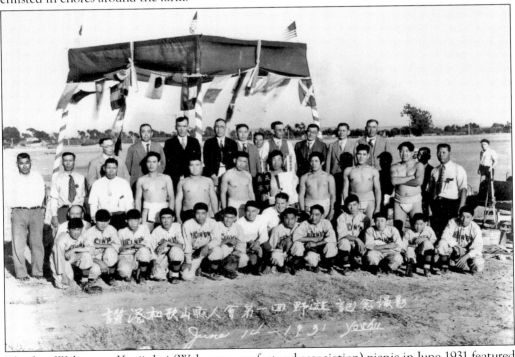

讃湛和歌山縣人會第一四野遊記念撮影
June 14 - 1931 yoshii

The first Wakayama Kenjinkai (Wakayama prefectural association) picnic in June 1931 featured baseball and sumo.

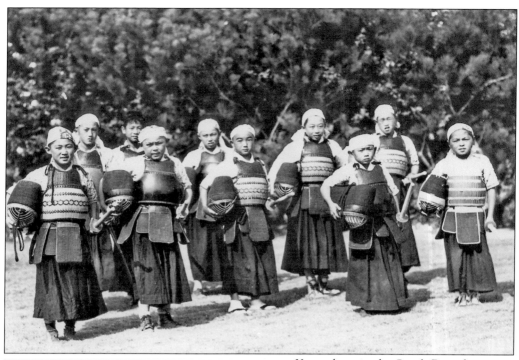

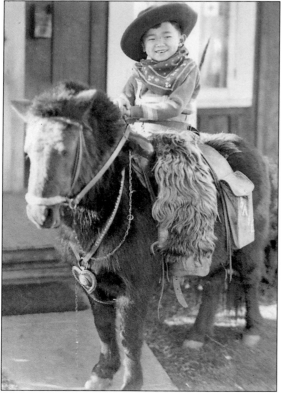

Young boys in the South Bay often spent Friday evenings practicing kendo at the Chula Vista *gakuen* (Japanese-language school). For May Day 1932, Chula Vista students presented a kendo demonstration. Athletes are, from left to right, (first row) Paul Ozaki, Torao Nakagawa, George Yamada, and unidentified; (second row) Kazumi Yamada, Sam Hirase, Isao Nakagawa, Shig Yamanishi, Shoichi Yonekura, and Masanobu Tanaka.

Issei parents instilled typical Japanese characteristics of hard work, cultural pride, and frugality into their children, but they also believed their children were American and partook in what they thought were typical American activities. A door-to-door salesperson sold photograph mementos of boys dressed in a cowboy outfit posing with a pony in the 1930s, and Motoo Tsuneyoshi's parents kept this photograph of their little cowboy.

Issei farmers in the South Bay wanted their children to learn the Japanese language. Otokichi Kushino, Suekichi Ogino, and Suekichi Iwashita initiated a drive to raise funds to create a Chula Vista Japanese-language school (*gakuen*) in 1925. The photograph features the *c.* 1930 high school classes. Former Japanese school student Arnold Watanabe recalls, "My mother taught from 1935–1940. She taught the grammar school students on Monday, Wednesday, and Friday after their regular classes were over. The high school students went to class all day on Saturdays." The *gakuen* became a community center, with agricultural cooperatives and other Japanese organizations conducting meetings and activities there. One former student remembers, "The best times were lunch hour where we would play games like capture-the-flag, kick-the-can, and marbles. After school, they would line us up in rows to be dismissed."

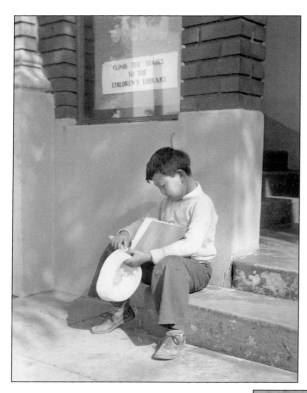

The San Diego Public Library children's library was a favorite hangout for many Nisei living downtown. Jack Watanabe sits on the library steps reading a book.

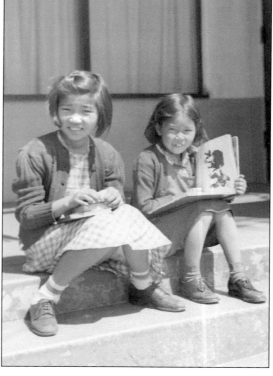

Lilian Kawasaki (left) and Mariko Yanagihara Tanizaki (right) spent hours at the downtown library and befriended Clara Estelle Breed, head of the children's library. Children adored "Miss Breed," as they all called her, and she was a lifeline for many Nisei during the difficult years of World War II.

Tokio Yano (standing) and his younger brother Tad (sitting on Tokio's shoulders) often enjoyed the rural Mission Valley environment when not helping their parents on the farm.

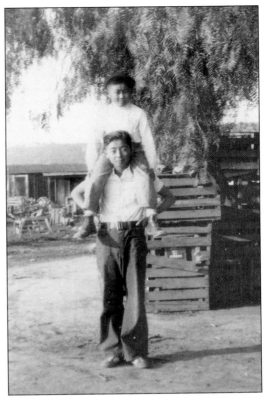

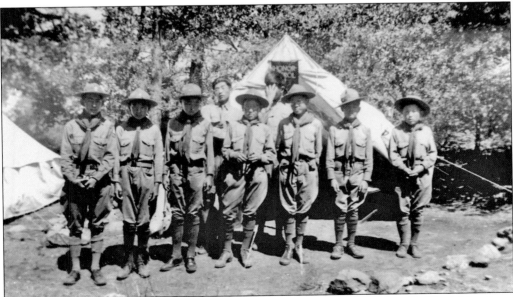

The First Japanese Congregational Church sponsored Boy Scout Troop 52. Nisei Motoharu Asakawa (second row, far left) was the first Japanese American in San Diego to achieve the Boy Scout Eagle Scout rank in 1935. He went on to lead this troop (pictured) and mentor other Boy Scouts.

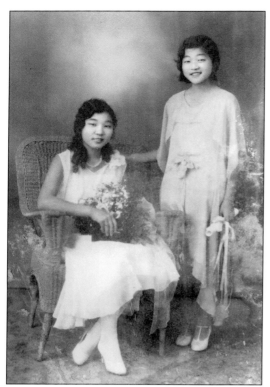

San Diego Nisei conducted mixers and socials with other Nisei groups in the Southern California region. Florence Umezawa (standing), of the Calexico Union High School, and her sister, Lillian (seated), posed for this 1934 graduation photograph. Florence Umezawa married Motoharu Asakawa in 1940.

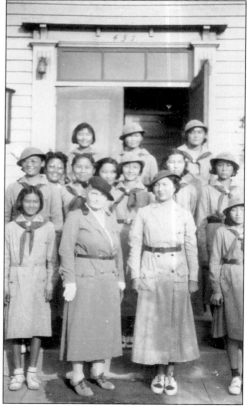

The First Japanese Congregational Church also sponsored Troop 8, a Girl Scout troop, in the 1930s. Yone Esaki Shiwotsuka (third row, center) became a Scout leader.

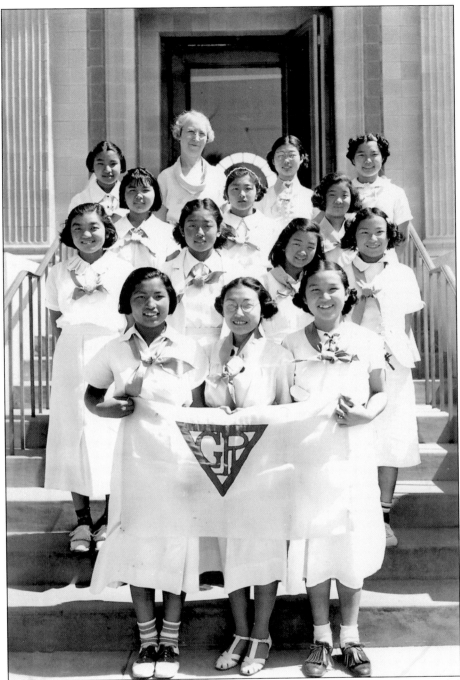

The Chula Vista Girl Reserves took field trips to places in Central and Northern California. The members are, from left to right, (first row) Haruya Hirai, June Kushino, and Kikue Fujiura; (second row) Dorothy Umezawa, Lilian Oyama, Hatsune Kamiura, and Edith Kushino; (third row) Chiyoko Fujiura, Michiko Date, and Midori Kamiura; (fourth row) Mariko Iwashita, ? Peters, Fumi Nikune, and Toshiko Iwashita.

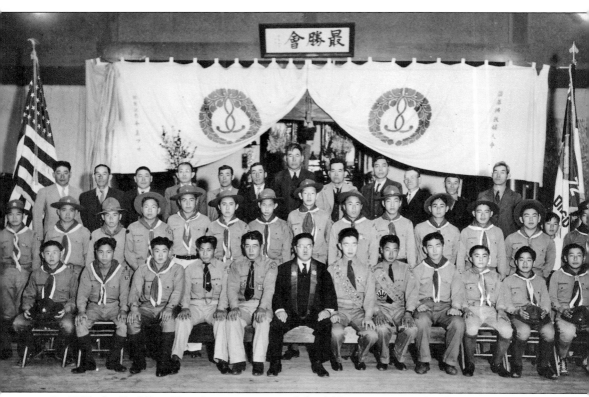

最勝會

In 1938, the Buddhist Temple commemorated the fifth anniversary of its Boy Scout Troop 72.

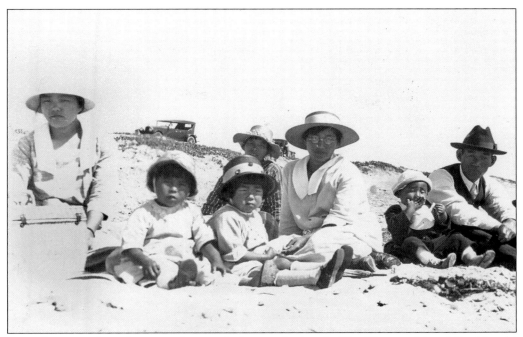

Issei often wore long dresses and sports jackets at the beach. The Tsuneyoshi and Hashiguchi families enjoyed a picnic on Coronado's Silver Strand.

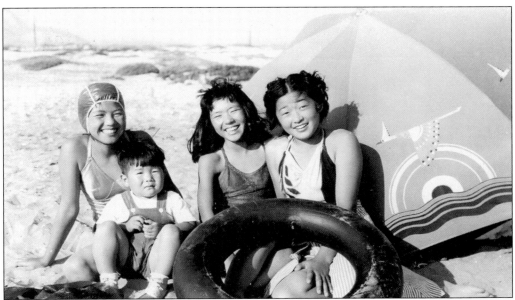

Nisei, on the other hand, who were coming of age in the 1930s, adopted the latest fashions in swimsuits and sponsored picnics specifically for young people. From left to right, Anne Kikuchi Yamauchi, Matthew Sato, Ruth Sato Fukuchi, and unidentified soak up the sun on a Coronado beach around 1935.

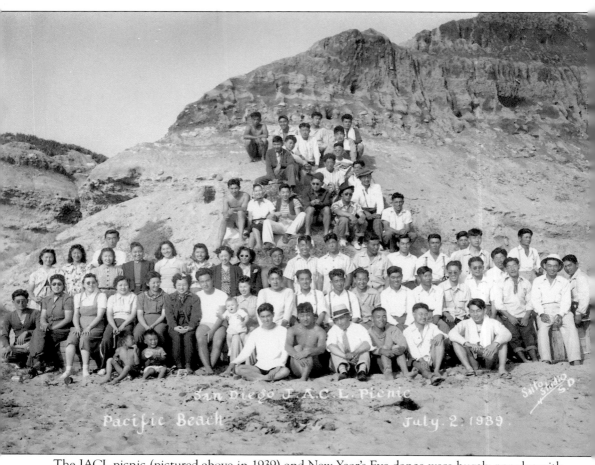

The JACL picnic (pictured above in 1939) and New Year's Eve dance were hugely popular with Nisei. The annual Fourth of July picnic brought Nisei transplanted to far-off cities like Oakland back to San Diego to visit friends and family. Under the leadership of Pres. George Ohashi, the JACL spearheaded a voter registration drive in 1936.

Take "Gooch" Taniguchi played organized football when he was not helping his family in the fishing supply business.

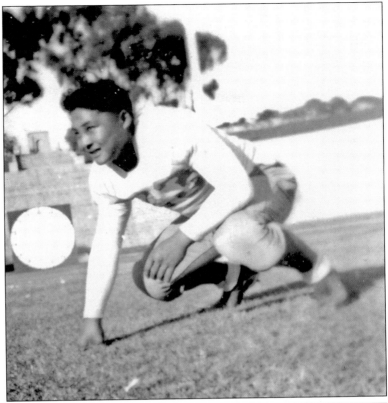

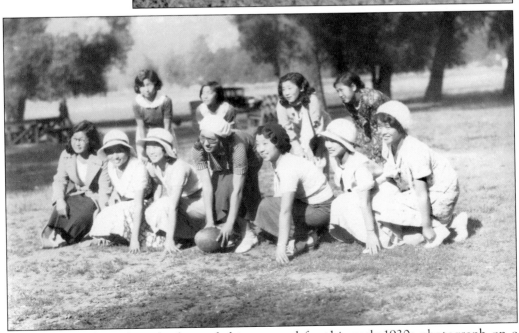

Nisei women dressed in the latest fashions posed for this early-1930s photograph on a football field.

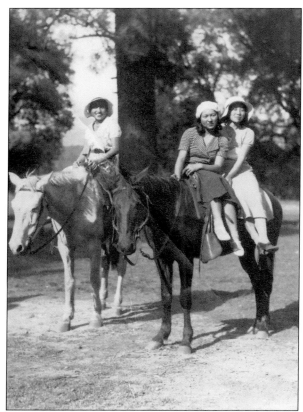

Young women were still under the control of strict Issei parents, but through group activities and student associations, they explored different experiences in San Diego. Elsie Hirai (far left) and friends enjoy a horseback ride in the 1930s.

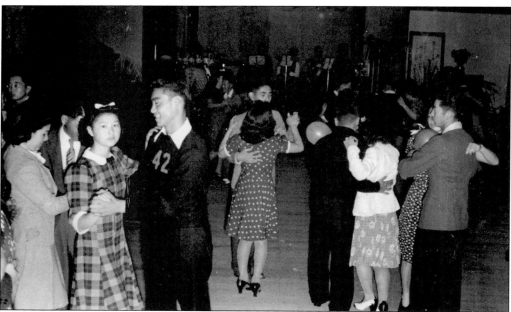

Young people held their own parties and danced to the latest big-band music. Mits Adachi Yoshioka danced with an unidentified young man wearing a No. 42 sweater in the 1930s.

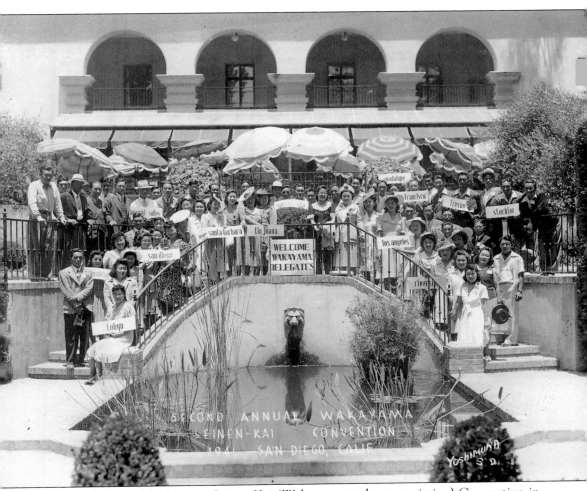

The Second Annual Wakayama Seinen-Kai (Wakayama student association) Convention in 1941 in Balboa Park attracted young people from throughout the state and even internationally. Note signs from Tokyo, Yokohama, and Tijuana. Seinen-Kai at local public schools sponsored skating parties, teas, and dances.

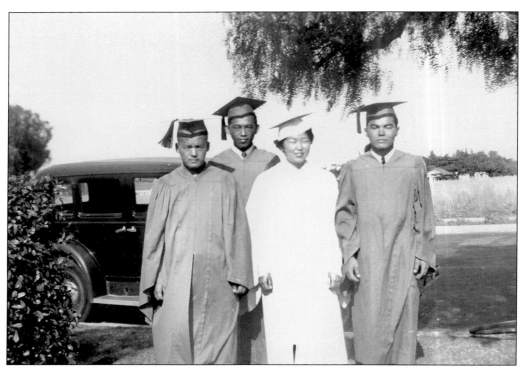

From left to right, Mas Koba, Haruki Koba, Fusako Tsuneyoshi Inouye, and Hide Takeshita celebrate their graduation from Coronado High School in 1939.

WANTED + NISEI

Reliable and experienced fruit stand worker, for full time work. See Mr. Paul Kuyama, 2869 Imperial Avenue. Phone : Franklin 2492 or Hilcrest - 1712.

Even though many Nisei were college educated, many mainstream businesses did not hire ethnic minorities. In an interview many years later, one Nisei reminisced about coming of age in the 1930s. He remembers, "In those days, the only opening was either a fruit stand run by a Japanese retailer, wholesale market, or farming."

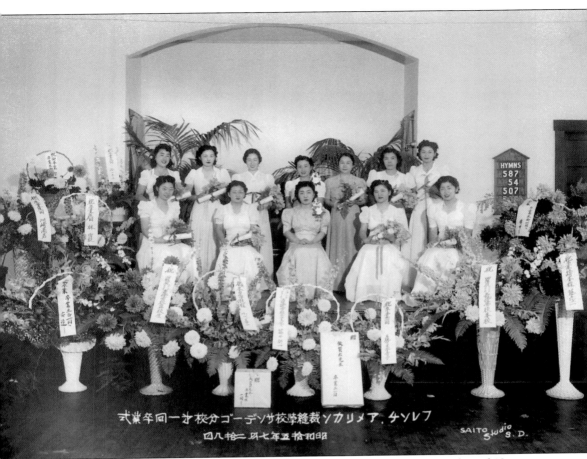

式業卒回一第校分ゴーヂンサ校学縫裁ソカリメア、チンレフ

昭和拾五年七月二拾八日

SAITO Studio S.D.

The newly opened French American Sewing School in downtown San Diego graduated 12 young women in 1940. Students are, from left to right, (first row) Umeko Mamiya Kawamoto, Yukie Honda, Kazumi Minamide, unidentified, and Fusa Tsuneyoshi; (second row) Yoshiko Nakamura, Yone Esaki Shiwotsuke, unidentified, May Fuji, unidentified, Betty Hashiguchi, and unidentified. Congratulatory baskets from friends and family surround the eager graduates in a ceremony held at a local Christian church.

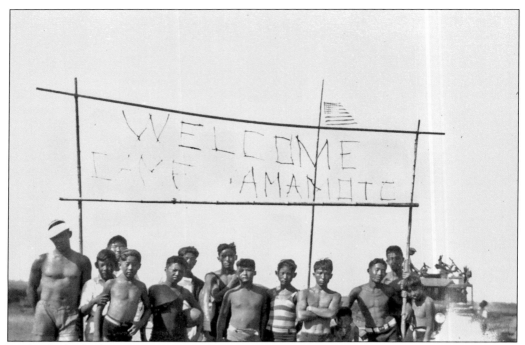

Under the leadership of scoutmaster John Yamamoto, Boy Scout Troop 52 enjoys outdoor activities at the Tijuana Slough during the hot summer months of 1939.

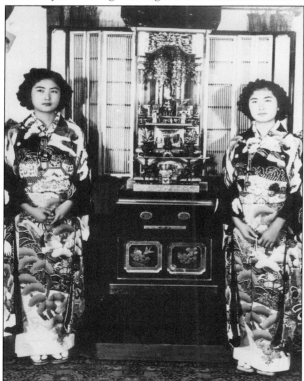

While Nisei were more comfortable in typical American clothes, special occasions were a time to dress in traditional Japanese kimonos. Twins Kikue Kawamoto Koga (left) and Haruko Kawamoto Urata pose in front of the large family Buddhist altar in 1940. The Kawamoto family ran the popular Frisco Café in downtown San Diego.

Five

"ALIENS INELIGIBLE FOR CITIZENSHIP"

Anti-Japanese sentiment was part of a larger anti-immigrant movement in the late 19th and early 20th centuries targeting almost every ethnic immigrant group. By the turn of the 20th century, Chinese laborers were prohibited from entering the United States, and within the first decade of the new century, under the 1908 Gentlemen's Agreement between the United States and Japan, Japanese laborers were no longer welcome. The Immigration Act of 1924 closed the door to Japanese immigration and severely limited emigration from other "undesirable" areas, namely southern and Eastern Europe.

California state laws and U.S. Supreme Court decisions ensured that Issei would remain second-class aliens in their adopted country. In 1913, California enacted its first Alien Land Law, and other states soon followed. The 1913 Alien Land Law prohibited "aliens ineligible for citizenship" from purchasing land and limited land leases to three years. The term "aliens ineligible for citizenship" was a euphemism for Issei and other undesirable immigrants from Asia. The 1922 U.S. Supreme Court decision *Ozawa v. United States* ruled that Issei were not allowed to become naturalized U.S. citizens; this right was reserved for "free white persons."

In 1920, the California legislature updated the land laws to close the loopholes that made it possible for Nikkei land ownership. Although the 1920 Alien Land Law made it difficult for Issei farmers, they devised methods to secure land and continued to increase their acreage in agriculture. One of the most popular methods of overcoming the Alien Land Laws was naming American-born children as owners on land deeds. Another strategy was finding Caucasian or Nisei partners to acquire land.

Exclusionists also targeted Issei fishermen with changes in the Fish and Game Code and other legislative attempts to restrict Issei involvement in the fishing industry. Local Issei community leaders like Tokunosuke Abe were at the forefront in defeating anti-Japanese state codes and legislation. Despite oppressive legal restrictions and anti-Japanese sentiment, Issei still saw San Diego as a place of opportunity and firmly established a home there for their Nisei children.

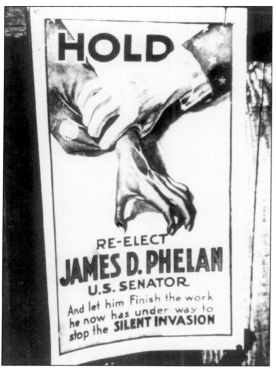

James Phelan, a three-term mayor of San Francisco and one-term U.S. senator, was a vocal proponent of the 1920 Alien Land Law and successfully lobbied for the termination of picture bride marriages in 1920. Politicians and other economic interests, afraid of Japanese competition in agriculture and fishing, fanned the flames of anti-Japanese sentiment with fears of the "silent invasion."

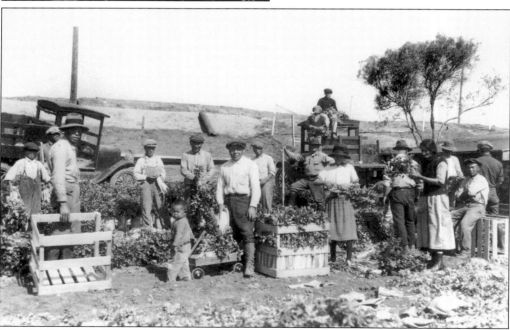

In spite of anti-Japanese sentiment, Issei farmers proliferated and planted numerous truck crops, including the celery pictured in this 1920s photograph. The cooperative strategies of Issei farmers and the tradition of enlisting the entire family in harvesting and packing efforts drew the ire and resentment of Caucasian farmers.

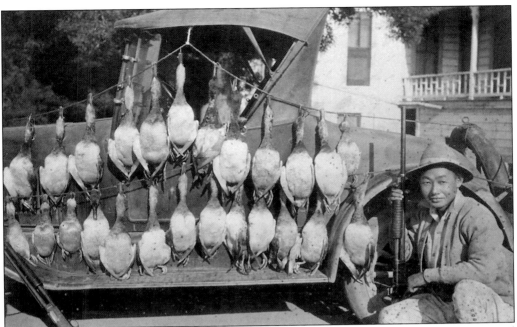

Born in Hawaii and therefore a U.S. citizen, Jerry Tasaki (pictured) and other Nisei were recruited to sign leases for Issei farmers. Tasaki helped numerous Issei farmers lease land to get around Alien Land Law restrictions. As an older Nisei in the community, Jerry was friendly with many Issei and was an avid hunter in the San Diego Japanese Gun Club.

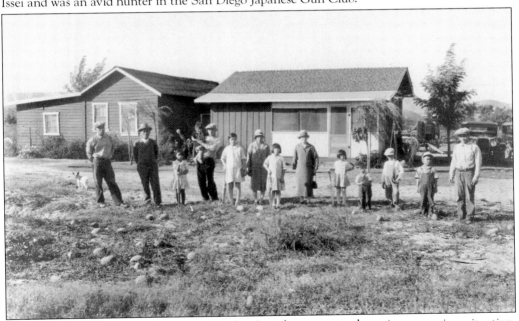

Even though they followed the letter of the law, Issei farmers were always in a precarious situation. In 1928, the district attorney prosecuted three Issei farmers in Vista for violation of Alien Land Laws even though the title was held by a Nisei. The three-generation Yasukochi family (pictured) farmed several different areas of North County in the 1920s and 1930s.

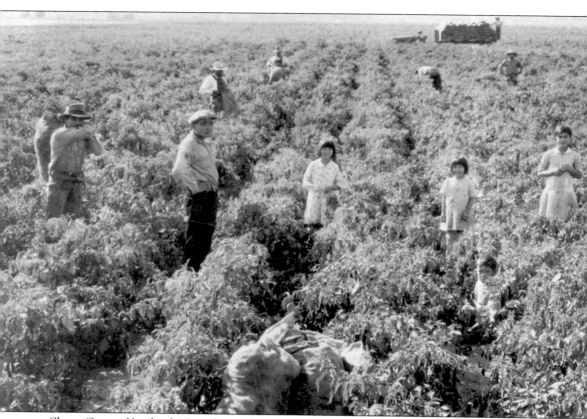

Shozo George Yasukochi (standing at left) farmed chili fields in San Luis Rey around 1938. Other Japanese farmers grew tomatoes, peas, strawberries, and squash. A cluster of 10 to 20 Nikkei families in Oceanside was dubbed *Kumamoto-mura* (*Kumamoto* is a Southern prefecture in Japan and *mura* means village). Wanting their children to learn the Japanese language and proper "filial piety," the Issei built a *gakuen*, or Japanese-language school, by the late 1920s. With the increased anti-Japanese sentiment of the 1920s, Issei wanted their children to speak Japanese in case the family had to return to Japan. Shozo recalls, "It was a family-oriented farm, and the father, mother, children, everyone in the family worked in the fields."

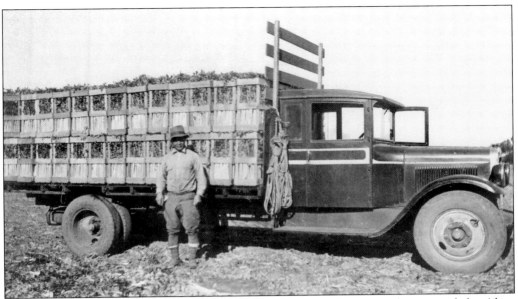

Caucasian farmers did not want competition from Japanese farmers and supported the Alien Land Laws. As Chula Vista became a prosperous farming community, it was also known as the "Heart of the Anti-Japanese Movement." Toraichi Ozaki of Chula Vista poses with his truck full of celery crates in 1934.

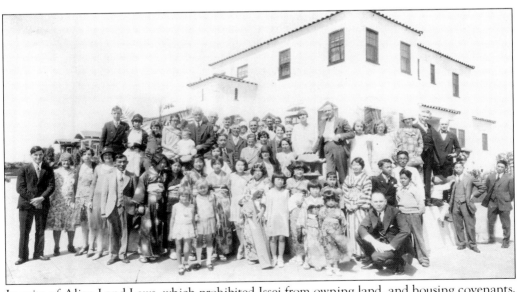

In spite of Alien Land Laws, which prohibited Issei from owning land, and housing covenants, which restricted who could live in certain neighborhoods, a handful of Nikkei families were able to purchase homes. Tsunejiro Yamasaki threw a huge open-house party in this neighborhood east of Balboa Park in 1930.

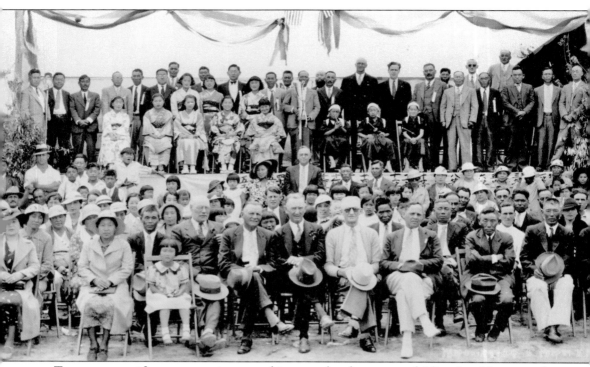

To counter anti-Japanese sentiment and increased enforcement of Alien Land Laws, an Issei farmer, Tsuneji Chino, initiated a plan to "change an anti-Japanese town into a friendly town." Issei farmers gave back to the community in the form of financial support to schools, parks, and libraries. Chino's farming efforts improved the quality of celery produced and earned a special designation from the California Agricultural Department. Finally, in 1932, Chino convinced Issei and Caucasian farmers to cooperate and form the Chula Vista Celery Growers Union. Celery growers, farm families, and the local community came out for the first Chula Vista Celery Growers Union picnic in 1936.

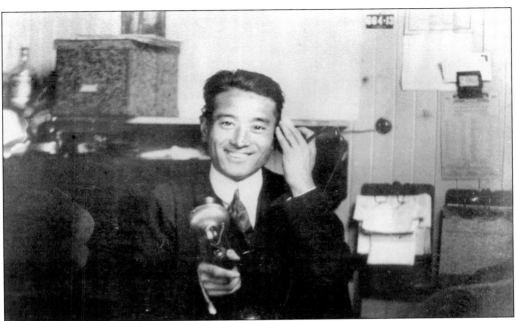

Tokunosuke Abe, a leading pioneer in the local tuna industry, established the Southern Commercial Company in 1933. Throughout the 1930s, he waged a battle in the courts and political arena to stave off numerous restrictions targeting Issei fishermen.

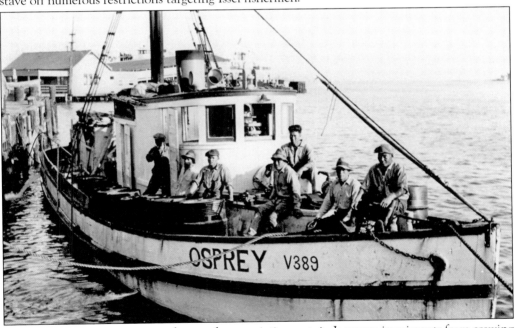

Anti-Japanese proponents passed a state law restricting certain Japanese immigrants from crewing fishing boats. Abe, along with the JACL and other fishing interests, took their case to court, and the state Supreme Court ruled in his favor, defeating the restriction on Issei residential status. One of Abe's boats, the Osprey (pictured here in 1938), was at the center of the landmark state court decision.

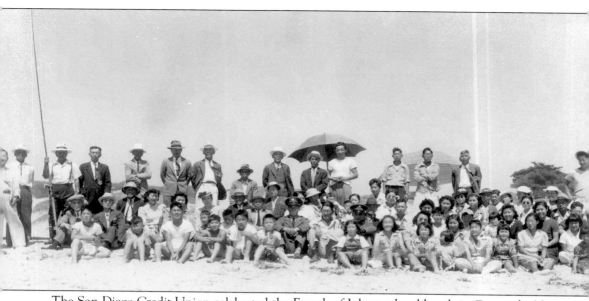

The San Diego Credit Union celebrated the Fourth of July at a local beach in Coronado. Nisei men serving in the U.S. military sit prominently in the middle of the photograph. Shortly after the Japanese attack on Pearl Harbor on December 7, 1941, Nikkei residents presented the Coronado City Council with the following resolution: "Whereas, we being resident aliens of the country and community for the greater part of our lives, and being parents of American citizens, do hereby pledge our resources, our children, and our lives towards the victorious conclusion of the war upon the Axis nations. Furthermore, we pledge our wholehearted support towards civilian defense, Red Cross and all city, county and national agencies devoted to national unity and defense."

Six

WORLD WAR II
AND EXILE

As news of the Japanese attack on Pearl Harbor on December 7, 1941, rippled throughout the nation, Nikkei in San Diego felt an immediate impact. FBI agents summarily rounded up Issei leaders, including fishermen returning to San Diego Bay. On December 8, the local newspaper announced the imprisonment of 45 Japanese men in the county jail.

As ordered by the military, San Diegans of Japanese ancestry reported to the Santa Fe Railway Depot on April 8, 1942. Nikkei families lost everything: businesses, farm crops, and possessions. Regardless of citizenship or previous military service to the United States, all persons of Japanese ancestry were evacuated from the West Coast. One Issei retells a conversation with a Nisei friend already in the army, who said, "It's bad enough to take my old man to the concentration camp, and having all the Japanese evacuated from the coastal areas, and even attempting to take your citizenship away, I don't know why I am in the Army. To my knowledge anyone born in this country is an American. I want to see democracy as it was supposed to be."

Uprooted to the Santa Anita Race Track for several months, San Diegans eventually found themselves in Poston, on the Colorado River Indian reservation in Arizona, for the duration of the war. In May 1942, authorities evacuated North County Nikkei directly to Poston. With a population reaching almost 18,000, Poston was the third largest community in the state of Arizona during World War II. Poston was one of two camps located on Indian reservations.

In addition to confining families to camps, the War Relocation Authority (WRA), the main agency in charge, attempted to resettle Nikkei outside of the West Coast exclusion zone. In 1943, Nikkei who completed a loyalty questionnaire could leave and find work in Mountain and Midwest states. Through this program, hundreds of Nikkei migrated to cities like Denver, Chicago, and Minneapolis. Unsure of the reception on the outside, most Issei remained imprisoned in desert camps.

Under the watchful eyes of armed military police, Yasuko Ishida (center with coat) along with other persons of Japanese ancestry gathered at the downtown Santa Fe Railway Depot for an unknown destination. Nikkei could only bring what they could carry and were prohibited from possessing cameras and radios.

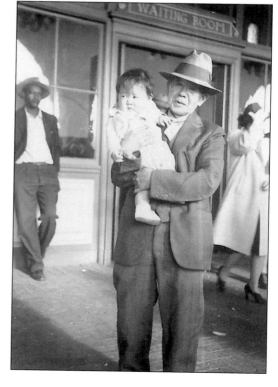

Magoichi Nigo holds Tomoe Carolyn Takasugi outside the waiting room at the train station. One Issei complained to a colleague, "They [meaning Uncle Sam] took my boy into the army, and now they take my other children to a concentration camp." Several Nikkei families already had sons serving in the U.S. Army during the evacuation.

Fusa Tsumagari and her brother, Yuki, said goodbye to San Diego children's librarian Clara Breed, who went to the train station to bid farewell to her adopted charges. She took numerous photographs of Nisei children and young adults, and gave out stamps and postcards.

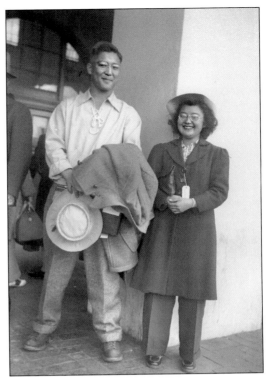

Clara Breed was a beloved friend to many Nisei throughout the war, and she often sent care packages of books and clothes to her camp pen pals. She also wrote numerous letters lobbying for the reunification of Issei fathers, incarcerated in segregated Department of Justice camps, with their families.

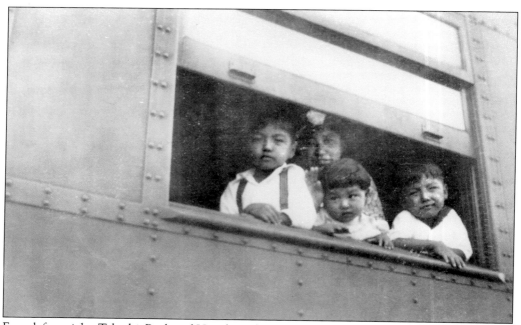

From left to right, Takeshi, Paul, and Hiroshi Kida wave to friends who came to say goodbye at the Santa Fe Railway Depot. Evacuees arrived at the Santa Anita Race Track, and horse stalls became their new home. Eleven-year-old Ben Segawa remembers, "The first thing you smell is the pungent odor of the horse urine and it stays with you. . . . I mean that smell will never go away."

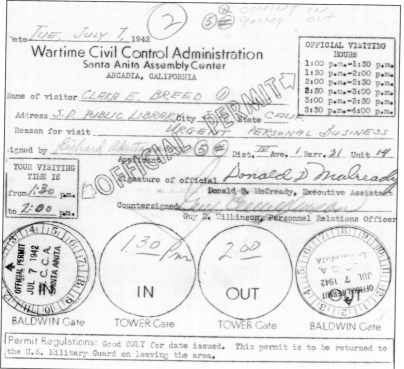

After months of trying, Clara Breed obtained a pass to visit her friends at the Santa Anita Race Track. The 30-minute visit flew by as children shared stories of life behind barbed wire and under the watchful eyes of armed military police. At night, glaring spotlights tracked children as they went to the communal toilet.

Pat Goto Takeshita drew this sketch of the Santa Anita grandstand. The track was the former home to world-famous racehorse Seabiscuit, but the new occupants found much to be desired. Nisei Ruth Takahashi Voorhies laments, "When I first saw my new home, and I saw the straw coming out of the walls, I just stood there and cried."

After evacuees spent several months at Santa Anita, special trains transported them to Poston, Arizona. The War Relocation Authority built the largest of the 10 internment camps on the Colorado River Indian reservation. Guard stations checked all vehicles and people entering Poston. The camp was divided up into Poston I, II, and III, and most San Diegans lived in Poston III. (Photograph by Paul Shintaku.)

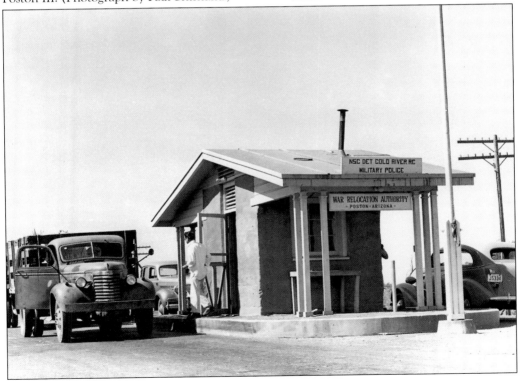

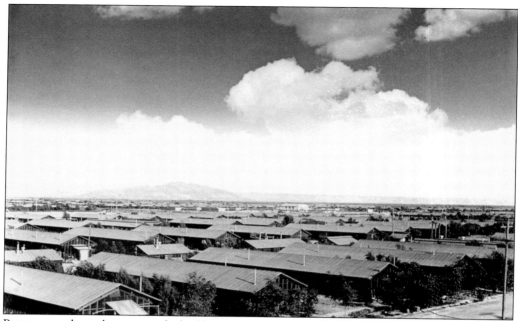

Poston was the only camp with double-layer roofs. Robert "Bob" Shimamoto recalls, "My most vivid memory of camp is the wind storms lifting the roofs off the barracks. The men quickly ran out to grab the wood to make furniture for our barren, one-room 'homes'." (Photograph by Paul Shintaku.)

Rains quickly turned the dirt pathways to mud. Fathers and uncles built traditional Japanese *geta* (wooden slippers) from scrap wood to walk to the communal showers and toilets, which had no partitions and lacked any type of privacy. Families lived in a one-room section of a barrack with a lone lightbulb for illumination. (Photograph by Paul Shintaku.)

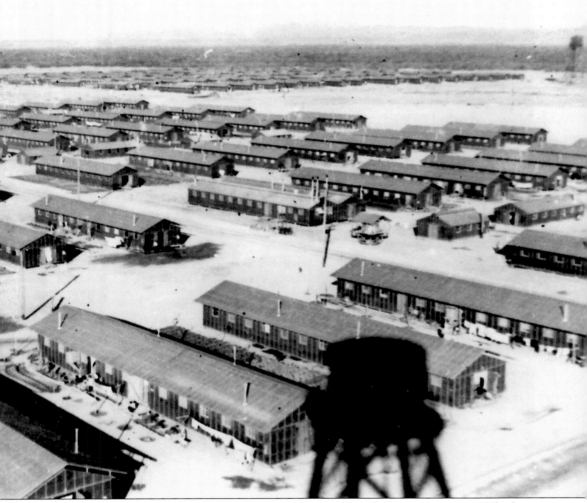

Out in the Arizona desert, Issei Shozo George Yasukochi of North County recounts, "The heat was bad enough, but the sand on top of that was just like hell. I wouldn't have any knowledge as to what an inferno would be like, but it couldn't be any worse than here." (Photograph by Paul Shintaku.)

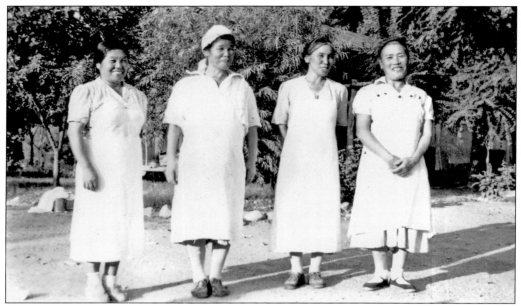

Issei women found jobs in various camp services. The WRA implemented a monthly wage scale of $12 a month for unskilled laborers, $16 for skilled labor, and $19 for professional employees. The kitchen crew is, from left to right, Fumino Honda, Yasu Akiyama, Suna Torio, and Asano Iguchi. Since all meals were cooked and served in the cafeteria, families no longer ate meals together, and family life suffered.

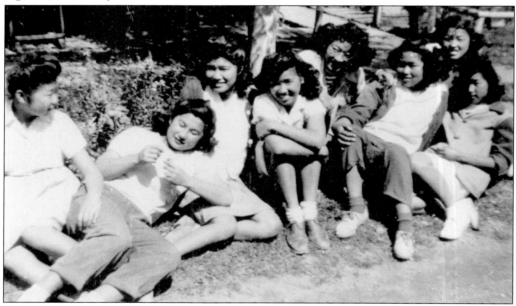

Out in the isolated desert, teenagers and young adults formed social groups to pass the time. The 329 Victory Gang, composed of girls from Block 329, deliberately wore short skirts to save on fabric and support the war effort. From left to right, Elaine Hibi Bowers, Elsie Sogo, Lily Iguchi, Elizabeth Kikuchi Yamada, Violet Takeda, Frances Toyama, Betty Kushino, and Fumi Takehara hang out.

In 1943, Tetsuzo Hirasake wrote to Clara Breed on weather conditions in Poston: "The dust storm came during the third week of January and lasted for three days. . . . we had the coldest morning yet when the temperature dropped to 20 degrees. That whole day ice was on the ground. Then it began to rain. It poured cloudburst after cloudburst for three days. The dust just turned into the stickiest mud I have ever seen." For protection against the elements, internees stuffed newspapers into cracks in the wooden walls and pounded the tops of canned food containers over holes in the floorboards. (Photograph by Paul Shintaku.)

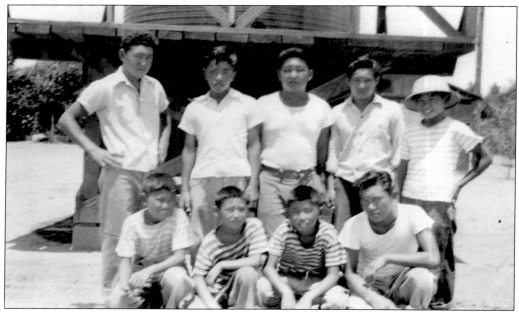

During the three years spent in camp, young people formed lifelong friendships. The San Diego gang is, from left to right, (first row) Jim Yanagihara, George Kido, Tom Yanagihara, and Hitose Suwa; (second row) Ben Segawa, Michio Himaka, James Kida, Jimmy Kido, and Yoshito Suwa.

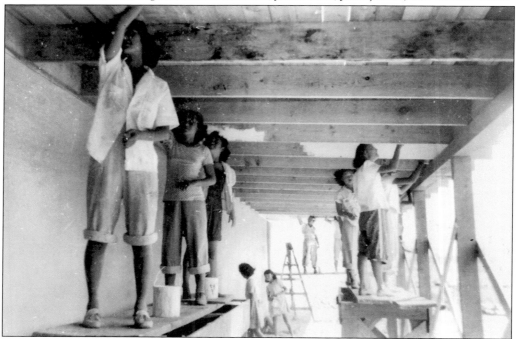

Everyone pitched in to complete the school buildings, and the school opened in October 1942. At first, chairs were scarce, and students had to bring their own chairs for daily lessons. In some grades, three students shared a textbook. In camp, Nisei teachers and other Nikkei professionals were paid far less than their non-Nikkei counterparts.

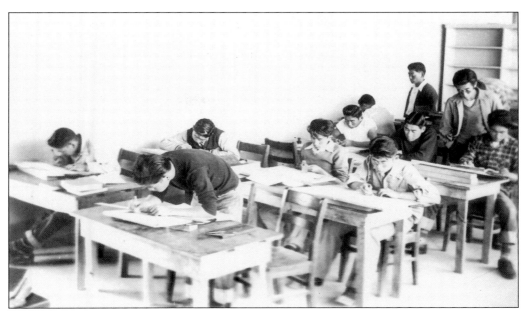

Students worked diligently in the high school drafting class. Terry Nishida (first row, center) went on to become a mechanical engineer. Other students included Eugene Yamada (second row, center), Ben Inouye (third row, center), and Shinobu Takeshita (third row, far left). Teachers and administrators were dedicated professionals who encouraged students to create a variety of extracurricular activities, including a newspaper, a band, sports teams, and a yearbook.

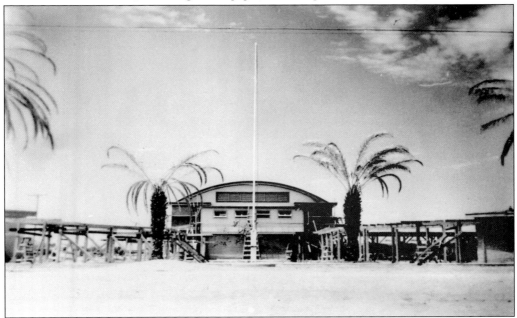

Detainees worked for more than a year in the adobe brick factory and at the school site to construct the Parker Valley High School Auditorium in 1944. The class of 1944 held their graduation ceremony in the auditorium. Internees also created an irrigation system for crops and built a community pool to help with the scorching summer heat.

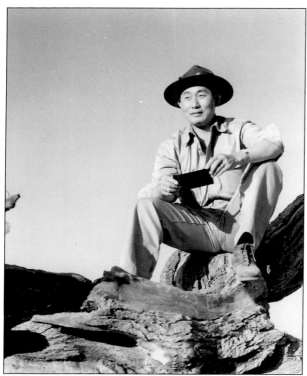

Paul Shintaku managed to smuggle in photography equipment and built a camera in camp. He took hundreds of photographs of individuals, families, and Poston scenery. Cameras were on a long list of banned items, but other internees ordered cameras from the Sears, Roebuck catalog and returning servicemen also brought back cameras for relatives.

Fukumatsu Nakamura (below, far left) watches as another Issei fisherman shows off his hooked carp. People hiked three miles to fish and picnic at the Colorado River. (Photograph by Paul Shintaku.)

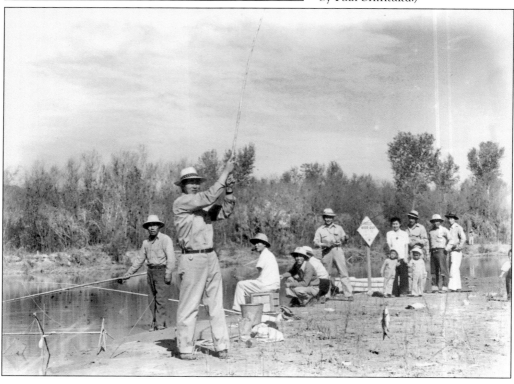

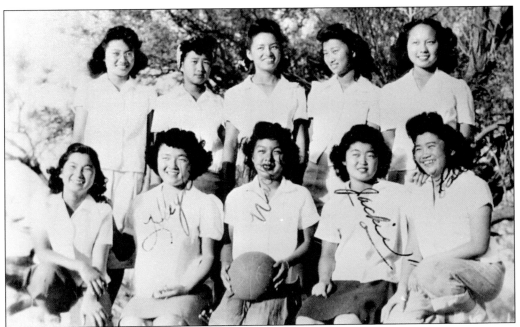

The Camp Activities Office implemented a comprehensive recreation program to stave off internee boredom. Men's and women's sport leagues were popular, and people of all ages played basketball and softball. The winning basketball team athletes are, from left to right, (first row) Elsie Sogo, Marion Fujimoto, June Hayashi, Helen Ozaki, and Pauline Date Nakamura; (second row) Violet Takeda, Fumiko Takehara, Jane Kushino, Sakiye Takehara, and Kat Kusamoto.

Nikkei created desert gardens in front of their barrack, and after two years, trees and a multitude of shrubs had come to life. Betty Aoyagi Shintaku is pictured in front of her barrack in 1944. (Photograph by Paul Shintaku.)

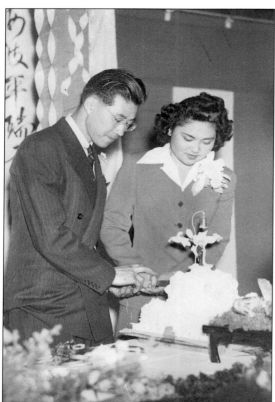

In 1945, Carl Kaoru Kada married Sakiko Okamoto. Since flowers were difficult to obtain out in the desert, family members created ingenious paper flower corsages to celebrate the festivities. Internees used whatever they could find in attempts to beautify their surroundings. Vegetable and fruit crate ends became the canvas of necessity for several camp artists.

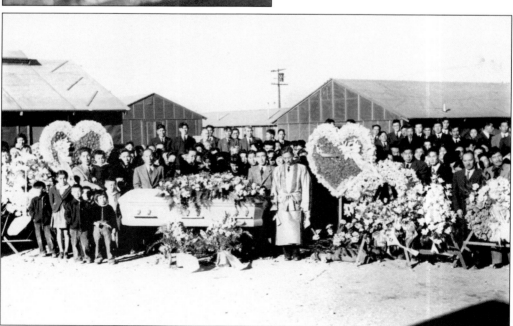

The circle of life continued in camp, and while births were a cause of celebration, deaths were mourned with paper flower wreaths.

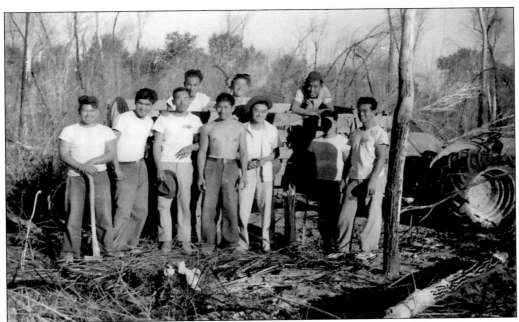

The brush cleaning crew created firebreaks and cleared hazardous brush. From left to right are (first row) Shizuo Akiyama, Joe Owashi, Fred Katsumada, Joe Yoshioka, Shig Yamashita, unidentified, and Oscar Aizumi; (second row) Bob Tanabe, unidentified, and Fred Iguchi.

While most San Diegans ended up in Poston, Akira Shima and his family spent World War II in the Gila River Relocation Center, also in Arizona. A skilled *sumi-e* (calligraphy) artist, Shima created posters for camp activities. This poster announced the Gila Players' Independence Day Variety Show. Detainees often reused posters to brighten up drab barrack rooms. Stripped of civil liberties, detainees still celebrated American holidays.

The Kawasaki brothers, Trace (left) and Seiso, share a happy moment in a series of family photographs. For young children, camp generally was a fun time spent hanging out with friends, but one Issei observed the impact of incarceration for adults as "the injury that was made on their hearts will take a long time to heal."

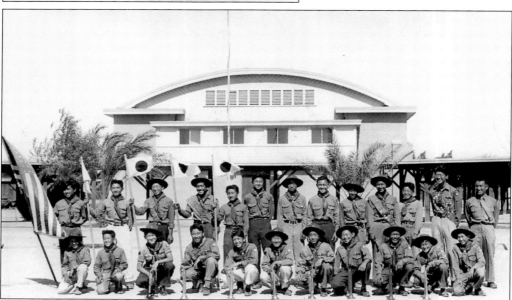

Boy Scout Troop 442, named in honor of the all-Nisei military unit, collected newspapers and cardboard for the war effort and delivered them to railroad cars in the nearby town of Parker. After they worked all day in the stifling heat, the scoutmaster took the troop to a restaurant, but the waitress refused to serve them. The signal flags, with large solid circles, are used for communicating across distances.

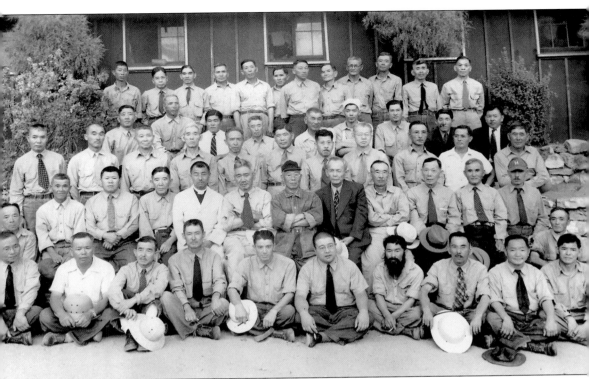

The Department of Justice created segregated camps for Issei community leaders. As enemy aliens, authorities treated these incarcerated Issei as prisoners of war. Authorities imprisoned most of San Diego's Issei leaders in the all-male Santa Fe Internment Camp (pictured) in New Mexico and the Crystal City Internment Camp in Texas. The long months, even years, of separation exacted a heavy toll on Nikkei families.

A nationwide labor shortage in 1942 enabled, from left to right, (first row) Tom Kida, Tad Yano, and Satoshi Kida; (second row) George Yano, unidentified, and Mits Hamaguchi to find temporary field work harvesting sugar beets in Lewiston, Utah.

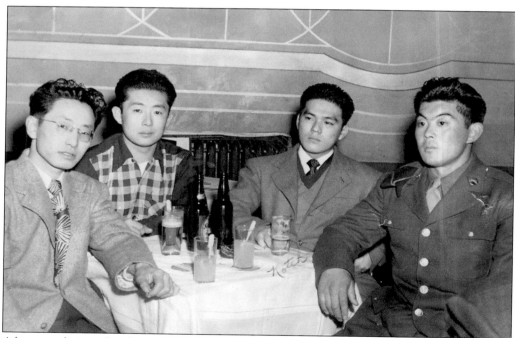

After completing a loyalty questionnaire and finding a job outside of the evacuation zone, many Nisei left camp for Midwest cities like Chicago, Denver, and Minneapolis. Chicago candy factories and hotels hired eager Nisei. From left to right, around 1944, Tom Sakaguchi, Art Ozaki, "Katcho" Koba, and Minoru Hatada rendezvoused in Chicago to catch up.

Seven

"SOMETHING TO BE PROUD OF"

Barred from military service, young men found jobs on camp work crews or as seasonal laborers outside of camp. A year after the signing of Executive Order 9066, which started the process of evacuation, Tetsuzo Hirasaki wrote San Diego Public librarian Clara Breed of the eagerness of Nisei men to prove their patriotism. Hirasaki stated, "When the Army came here to Camp III to register the men under selective service and also to take volunteers for the Japanese American combat unit, it was the best piece of news we Nisei have had in a long time. We Nisei were despairing on ever becoming recognized. But now we have the chance to prove our loyalty, because after the evacuation, Nisei were classed as aliens ineligible for military service."

The all-Nisei 442nd Regimental Combat Team and the Hawaii-based 100th Battalion (eventually merged into the 100th/442nd) became formidable fighting forces in the European theater and were one of the most highly decorated combat units for its size and duration of service in the history of the U.S. military. Fighting battles in Italy and France, Nisei received 9,486 Purple Hearts, 8 Presidential Unit Citations, and 21 Medals of Honor. San Diegans themselves proved their courage and bravery with Purple Hearts, Bronze Stars, and Silver Stars.

Nisei and *Kibei* (Nisei educated in Japan who returned to the United States) with Japanese-language skills were recruited for Military Intelligence Service (MIS) and were secretly deployed in the Pacific theater. Those holding anti-Japanese sentiments often looked upon Japanese-language schools and those with bilingual skills with suspicion, and branded them un-American; however, during the war with Japan, MIS interpreters and interrogators proved invaluable in the Pacific conflict.

Whether they enlisted or were drafted, Nisei earned the respect of their fellow soldiers. As PFC Lloyd Ito states, "Well that's the reason we went over—try to fix it, so that when they [families and the Nikkei community] came out of the camp that they had something to be proud of."

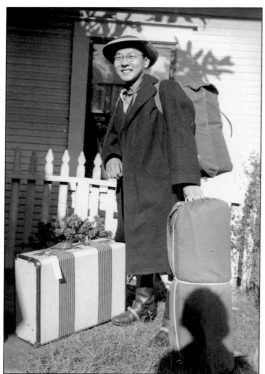

While his Issei father was incarcerated in a separate Justice Department camp in Santa Fe, New Mexico, Tetsuzo Hirasaki wrote, "I am proud to say that the San Diego group has the most volunteers than any other group in camp. All together in our block we have just about 15 volunteers, including yours truly, which makes about the best record yet."

In basic training at Camp Shelby in Mississippi, Nisei from internment camps and Hawaiians from the islands initially were fierce rivals. As basic training progressed, the mainland and Hawaiian Nisei were molded into a unified fighting unit. Nineteen-year-old Sam Yamaguchi (pictured) wears a Hawaiian ribbon lei.

Before shipping out to Europe, soldiers returned to Poston to see family members. Regulations required permission from the camp director for any type of visits, and armed military police stood guard as Nisei soldiers entered camp. In front of a Poston III barrack, Suna (left) and Yoshichiro (right) bid their son Frank Torio (center, in uniform) farewell.

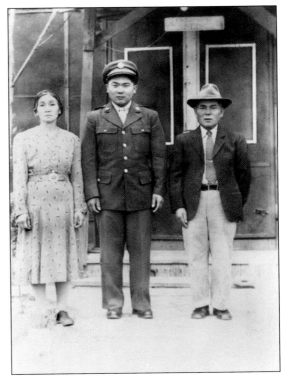

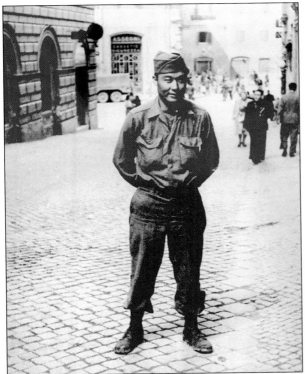

Citations and awards increased as Nisei fought their way through Italy. Awarded a Silver Star for his gallantry, Sgt. Bert Tanaka led a counterattack on entrenched enemy dugouts outside of Rome. His citation reads, "Sgt. Tanaka's daring and leadership in bringing the fall of this vantage ground enabled the platoon to move to a new position and gain its objective a short time later."

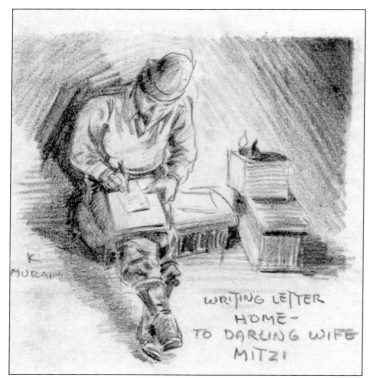

WRITING LETTER
HOME —
TO DARLING WIFE
MITZI

Originally from Hawaii but transplanted to San Diego, Bert Tanaka returned to Hawaii to enlist in the all-Hawaiian 100th Battalion. The 100th was the first all-Nisei fighting unit in Europe, and Tanaka was the first Nisei to receive a battlefield commission. K. Murai captured a quiet moment in this sketch of Tanaka writing his wife, Mitsue, who was living in Cambridge, Massachusetts.

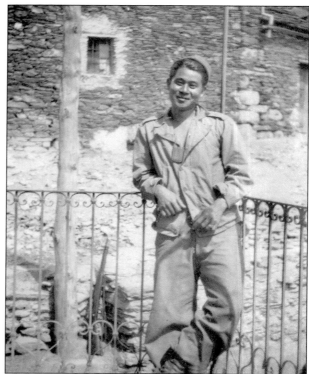

Serving as a replacement in the 442nd, Harry Kowase earned a Purple Heart for injuries sustained during combat in Bruyères, France.

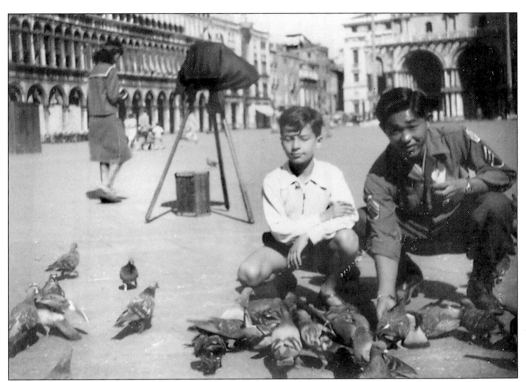

Frank Wada was one of the first to volunteer from Poston. Due to heavy casualties in his unit and his leadership skills, Wada went from second scout to acting platoon sergeant in less than a month in the Rome-Arno Campaign. In October 1944, Wada was wounded liberating the French town of Bruyères. Wada feeds pigeons in St. Mark's Square, in Venice, Italy, in 1945. (Courtesy of Frank Wada.)

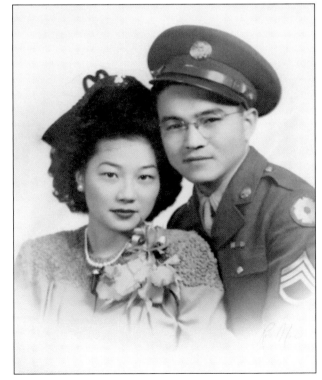

In 1943, Jim Matsumoto married Margaret Shimamoto in Rockford, Illinois. While he shipped off to Europe to prove his loyalty to the United States, she returned to Poston to be with her family. In an interview years later, Jim recounts, "Under no circumstances am I intending to glorify or dramatize war. It was one of the most miserable times of my life."

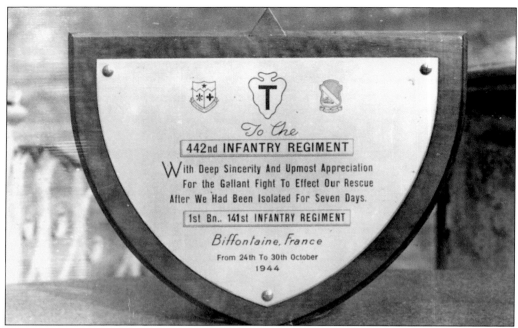

In October 1944, the 442nd went into battle to rescue the "Lost Battalion" in France. Deep in enemy territory, the 1st Battalion, 141st Infantry Regiment, was isolated with the enemy closing in. After three days of fighting, I and K Companies charged up a heavily fortified hill with fixed bayonets, shouting and yelling at the enemy. The direct assault secured the hill and successfully breached the German encirclement.

S. Sgt. Jim Matsumoto states, "K Company started the assault with over 200 men and ended with 8. In all, over 800 casualties were suffered by the 442nd in less than a week to rescue the 'Lost Battalion'." Matsumoto was awarded a bronze star for his bravery in rescuing a wounded soldier.

As a radio operator in the 442nd Cannon Company, Lloyd Ito fought campaigns in Italy and France. Although severely wounded from shrapnel, Ito continued his duties in the conflict to rescue the "Lost Battalion." Ito received a Purple Heart for his injuries and a Bronze Star for his courage and initiative. As with many of his friends, Ito's military service was his first experience traveling outside of California.

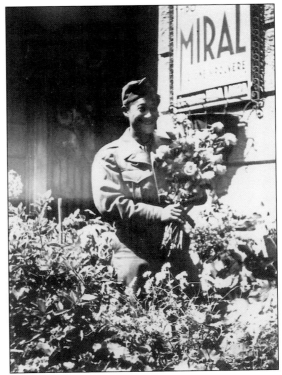

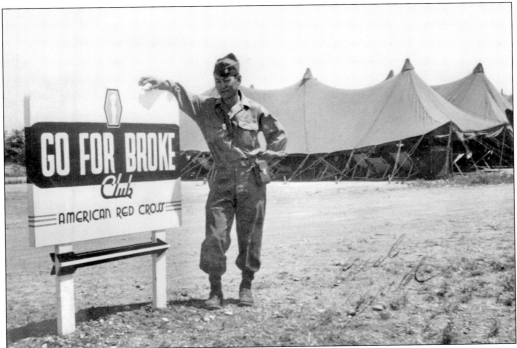

Drafted out of Poston, Fred Segawa proudly stands in front of the 442nd outpost in Leghorn, Italy. Segawa was part of the 442nd Service Company.

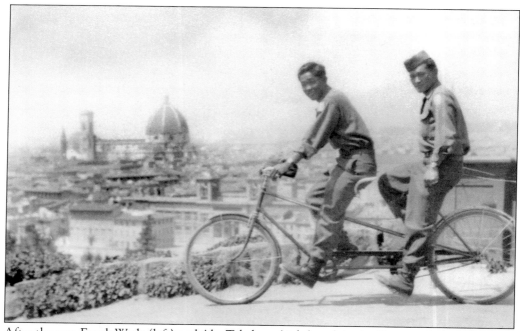

After the war, Frank Wada (left) and Abe Takehara (right) took in the Florence, Italy, sights with a famous cathedral in the background. Wada (442nd E Company) was a Purple Heart recipient who spent two months recovering in a Naples hospital. Takehara served in the 232nd Combat Engineer Company. (Courtesy of Frank Wada.)

Harry Kawamoto, a replacement in E Company, fought in Italy and France. In 1945, he returned to the United States to marry his fiancée, Umeko Mamiya. Each company was a tight-knit group who shared a lifelong bond. Kawamoto's family was pleasantly surprised when U.S. senator Daniel Inouye, also of E Company, greeted Harry warmly when both attended the 40th anniversary of the liberation of Bruyères in France.

Nisei women also volunteered for military service and served in the Women's Army Corps (WAC). Women worked as clerks, typists, medical assistants, and other support services. Shizuko Shinagawa (pictured left) served in Japan under Gen. Douglas MacArthur with the occupation forces in the WAC and as a civilian.

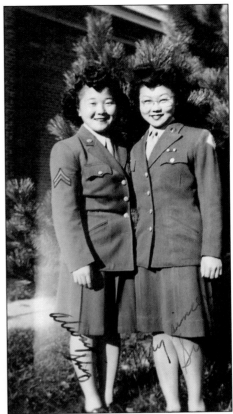

Toshio Abe dropped out of college to help his mother after his father, Tokunosuke Abe, died in 1940. He was drafted into the army the following year. While he went to basic training, his family was evacuated. Because of his Japanese-language skills, the Military Intelligence Service (MIS) recruited Abe for training as an interpreter at Camp Savage, Minnesota, and he served with Merrill's Marauders in Burma.

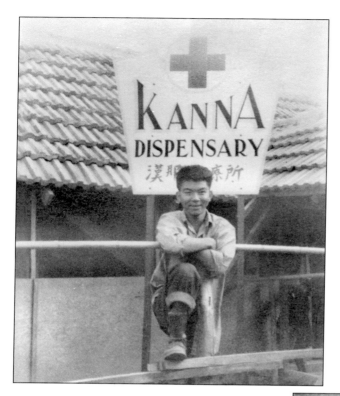

Drafted into the army while attending the University of Hawaii, Francis Tanaka served as chief medical interpreter on Okinawa from 1945 to 1947. Tanaka was part of establishing an aid station near the front lines and later set up a clinic, the Kanna Dispensary, for the Okinawan civilians. After the war, Tanaka attended medical school and established a medical practice in San Diego.

Hideo Ochi, drafted in July 1941, spent his military service with U.S. Army intelligence portraying Japanese soldiers in training exercises and military films in Hollywood. Ochi recalls, "All in all, I enjoyed my army life. I'm glad I was in the army. Recently, my wife and I went to Las Vegas and saw the Wayne Newton show. He asked all the World War II veterans to stand. It made me feel proud."

Eight

POSTWAR REBUILDING FAMILIES AND COMMUNITIES

With exclusion from the West Coast lifted starting in January 1945, internees in camps and Nikkei scattered to inland states had to decide whether to return to San Diego or to plant roots in other cities. Since the San Diego City Council had passed resolutions against the return of Nikkei to the region and the district attorney had filed Alien Land Law suits against several Issei farmers, detainees faced an uncertain future in San Diego. Yoshiko Kikuchi, wife of Rev. Kenji Kikuchi, expressed the following in a Japanese poem: "Should we go West to our old nest, Or should we go East to explore a new land. There may be a big storm tomorrow."

With the WRA closing Poston Camp II and III in October 1945, more than 900 Nikkei returned to San Diego, including the Kikuchi family. Internees leaving camp received $25, war-ration coupon books, and a one-way ticket to the destination of their choice. Arriving in San Diego, families faced a severe housing shortage and a city that had become what one tourist brochure touted as, "Defense City #1." Devastated by the economic and psychological upheaval of internment, many Issei businesses and families never returned to the Fifth and Island Avenues area in downtown San Diego that had once been the center of the community.

The postwar period brought several positive changes in the legal arena: the defeat of discriminatory Alien Land Laws and anti-miscegenation laws (laws against interracial marriage), and the U.S. Supreme Court decision rejecting restrictive housing covenants. In addition, the Walter-McCarran Act of 1952 paved the way for Issei naturalization. Nikkei churches responded by sponsoring citizenship classes for Issei.

Nikkei leaders slowly rebuilt community institutions, including the Christian churches and the Buddhist temple. Instead of a downtown enclave, religious institutions and community organizations like the JACL (Japanese American Citizens League) and sports teams became the heart of the Nikkei community. The growing numbers of *Sansei* (third generation) children were part of the national baby boom, and by 1950, the San Diego County Nikkei population had returned to the prewar number of approximately 2,000 persons.

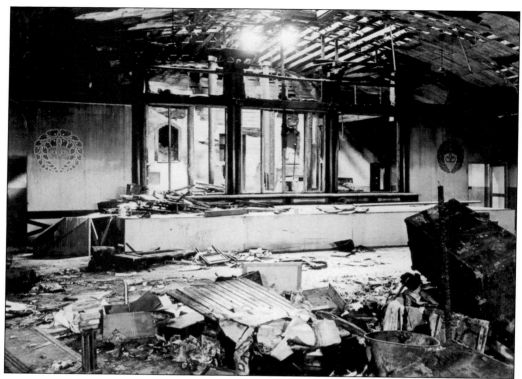

The Japanese Buddhist Temple suffered a fire in 1943; authorities suspected arson. Nikkei families had stored possessions in the temple during internment for safe-keeping, and many precious mementos were lost in the fire. After repairs, the USO utilized the building for an African American servicemen's club. During the late 1940s, temple members reclaimed the site and restarted temple activities.

Takeo Sugimoto was the first Nikkei to return to San Diego County in January 1945, as soon as evacuation orders were lifted. Sugimoto wanted to graduate with his fellow classmates at San Dieguito High School. After completing one semester of college, Sugimoto volunteered for the U.S. Army and served two years with the U.S. occupation force in Japan. Draft-age Nisei continued to perform their military service when called upon.

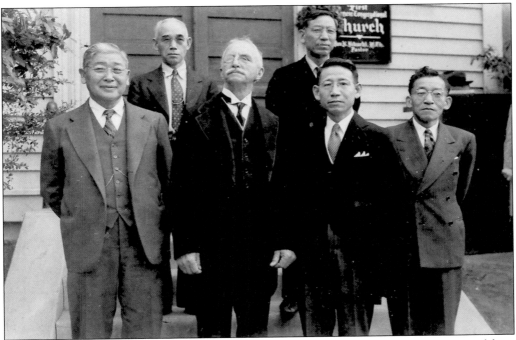

While the congregation was in exile in desert camps, Rev. Harris Rummel (first row, second from left) took care of the First Japanese Congregational Church building and all the belongings stored at the church. He welcomed back his fellow minister, Rev. Kenji Kikuchi (first row, second from right), who established a hostel for returning church members. Numerous Nikkei families lived at the church until suitable housing became available.

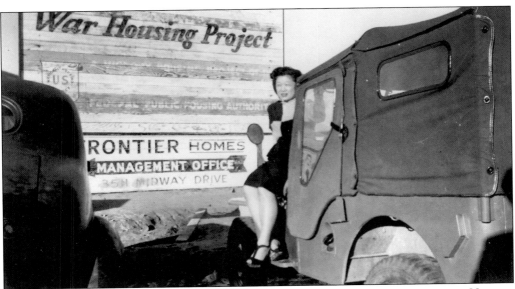

Originally built to house war industry workers during World War II, the Frontier Homes Housing Project, located in the Midway area, became home to many Nikkei families. Midori Koba Koga sits on a car in front of the housing office around 1947.

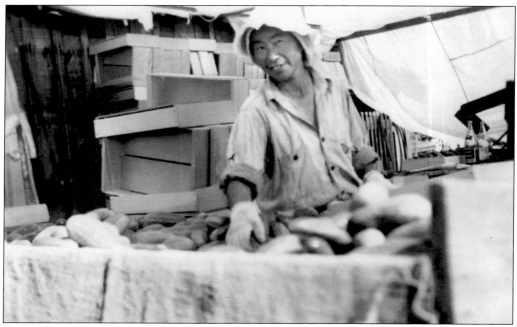

Koshun Sato (pictured in the late 1940s) and her husband, Mankichi, returned to Chula Vista in 1945. They had lost everything in the evacuation and slowly struggled to resume farming. Their son Kenji, who was discharged from the U.S. Army in 1946, returned to help his parents resume their farming business.

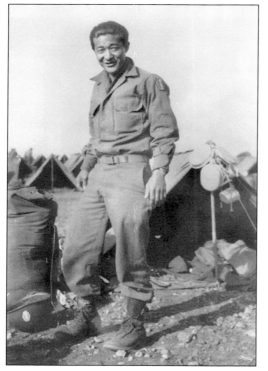

Army veteran Lloyd Ito returned to Encanto after the war. The local barber at first refused to cut Ito's hair. Upon hearing that the barber's son died in the war, Ito explained, "'I knew your son; he was fighting for the United States in Japan. I was fighting the Germans in Italy and France.' . . . From then on, we got to be real good friends."

James Yamate, an army corpsman with the 44th Infantry Division during World War II and a Bronze Star recipient, was originally from Modesto but relocated to San Diego with his parents after the war. The Yamate family started a successful farm in Chula Vista and helped revive the Japanese Christian Church.

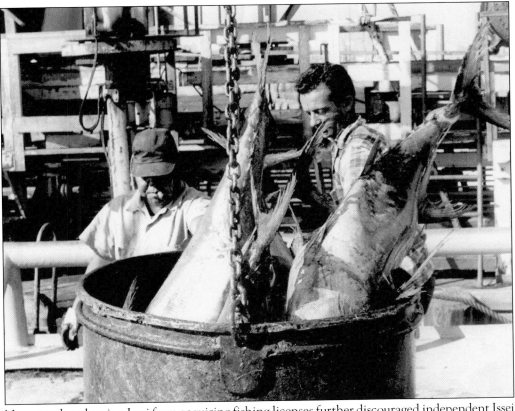

New state laws barring Issei from acquiring fishing licenses further discouraged independent Issei fishermen from reentering the business immediately following the war, but many Nisei returned to fishing. George Nakagawa (left) is pictured with his catch behind the Van Camp cannery around the 1950s. Fishing trips ranged from days off the coast of Mexico to months in the far-off South Pacific.

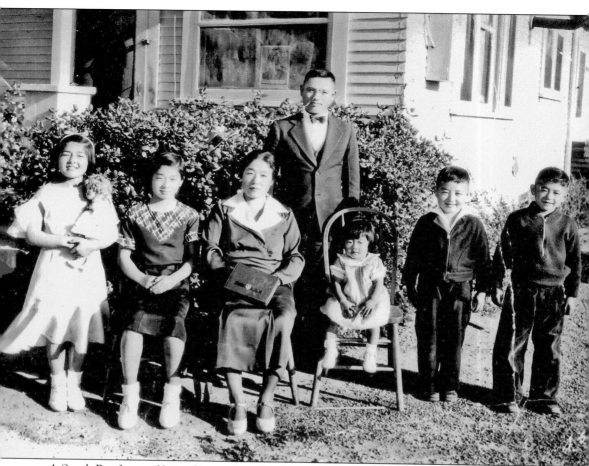

A South Bay farmer, Kajiro Oyama (standing), was instrumental in gaining greater equality for Issei farmers. After working with a Caucasian partner for close to a decade, Kajiro Oyama transferred title of his farmland to his minor son, Fred Oyama, in the 1930s. After World War II, the state confiscated the land because of the violation of Alien Land Laws. With the help of the ACLU (American Civil Liberties Union), Oyama pursued his case all the way to the U.S. Supreme Court. In 1948, the court ruled in favor of Oyama. Several years later, the California Supreme Court finally struck down the Alien Land Laws in a 1952 case, *Fujii Sei v. State of California*. Four years later, California voters repealed the Alien Land Laws. Alice Oyama Yano recalls, "The Oyama farm was the test case for the Alien Land Laws." The main Oyama crop was celery, but they also grew row tomatoes, hot-house cucumbers, corn, and string beans. The photograph of the family in front of the house on their farm was taken around 1934.

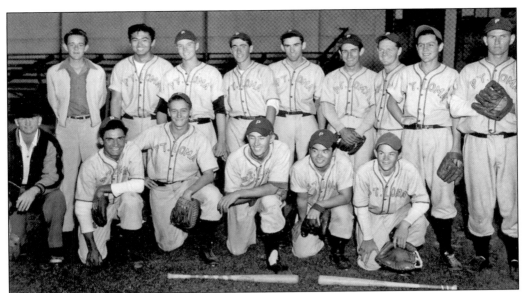

Star pitcher Po Kaneyuki (second row, second from left) and second baseman Yoto Takeshita (kneeling, second from right) led their Point Loma High School team to the championship of the Pomona Prep School Classic in 1947. Kaneyuki was the tournament MVP. Both Kaneyuki and Takeshita were selected to the All-Metropolitan League Team of the Breitbard Athletic Foundation, which later became the San Diego Hall of Champions Sports Museum.

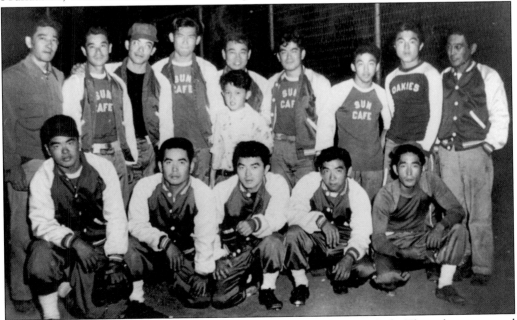

The Obayashi family returned to San Diego and reopened the Sun Café. They also sponsored the Falcons softball team. Shown here are, from left to right, (first row) Yoto Takeshita, Sam Takeshita, Akira "Jumbo" Takeshita, Shin Takeshita, and Ben Honda; (second row) Al Obayashi (sponsor), Harry Kowase, Walter Fujimoto, Isamu "Willie" Okamoto, Al Obayashi Jr., Kats Tanizaki, Hidetoshi Akiyama, Stanley Tsunoda, Swiss Nishiyama, and Masami Honda (manager).

Perseverance and hard work were key factors in reestablishing successful farms after World War II. Tom Kida drives his tractor on his Lemon Grove farm in the early 1950s.

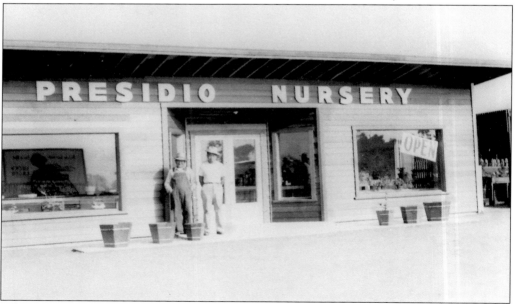

After several winters in Ohio, the Asakawa family returned to sunny San Diego to start the Presidio Nursery in Mission Valley in 1950. As the only retail nursery at the gateway to the growing suburbs of Clairemont and Linda Vista, the Presidio Nursery served the demand for plants and other landscaping products. Father Hashisaku (left) and son Motoharu Asakawa (right) stand in front of their newly opened nursery.

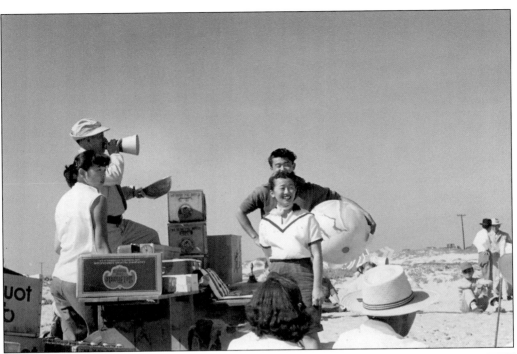

Members of the Pioneer Ocean View United Church of Christ (formerly the First Japanese Congregational Church) resumed picnics at local beaches. Nikkei picnics were not complete without a lucky number raffle at the end. Bags of rice and canned goods were popular raffle items. Fred Katsumata (with the megaphone) announced raffle names as, from left to right, Rose Seki, Judith Seki, and Joe Yamada distributed prizes.

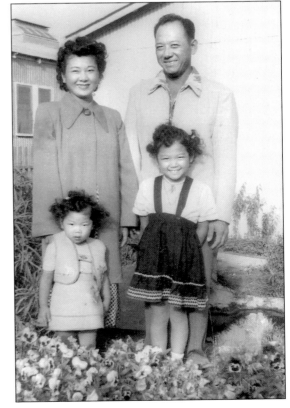

The Nikkei community increased in numbers with new Nisei families moving to San Diego. After farming in Imperial Valley for a number of years, Robert Shimamoto moved his family to San Diego in the 1950s for other economic opportunities. The Shimamoto family is, from left to right, (first row) Gwen Shimamoto Momita and Dale Shimamoto Cole; (second row) Margaret Miyaka Shimamoto and Robert Shimamoto.

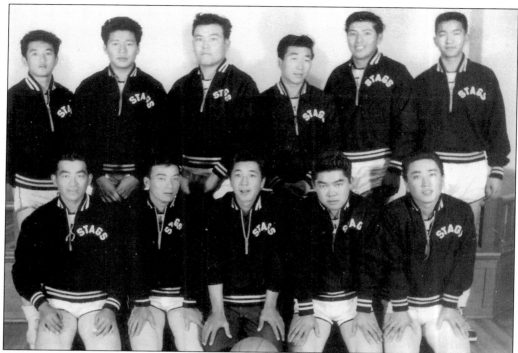

Nisei men's sports leagues continued into the 1950s and 1960s. The *c.* 1950 Stags players are, from left to right, (first row) Terry Koike, Tats Hirata, So Yamada, Ken Otsuka, and Ken Iguchi; (second row) Hank Yamada, Roy Iwashita, Jim Shinohara, Tosh Yonekura, Abe Mukai, and unidentified.

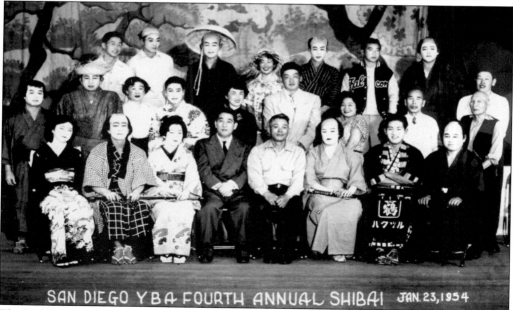

SAN DIEGO YBA FOURTH ANNUAL SHIBAI JAN. 23, 1954

The Buddhist temple restarted its theater program, and the annual *Shibai* (traditional Japanese play) was popular with members. Nisei player Motoo Tsuneyoshi (second row, second from left) remembers memorizing his Japanese lines phonetically and the appreciation of Issei audience members.

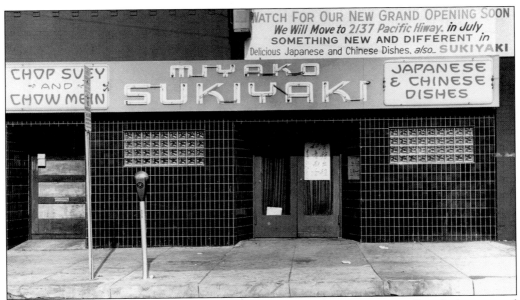

The ever-entrepreneurial Obayashi family opened the Miyako restaurant on Fourth Avenue and Market Street. Finding much success with a wide range of clientele, the restaurant moved to bigger facilities on the Pacific Coast Highway in 1960.

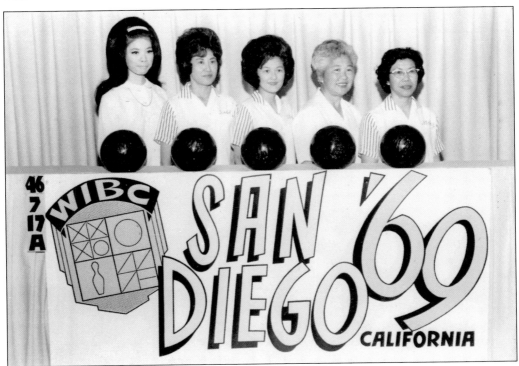

South Bay Glass of National City was the main sponsor for this winning Nisei team. Players are, from left to right, Jean Tani, Masako Uyeji, Lilly Sakamoto, Kiyo Ochi, and Miki Kitagawa. Nisei bowling teams often ate post-game meals at a favorite haunt, the Miyako.

Many Issei who were previously independent fishermen, farmers, or business owners were unable to return to their previous occupations after the upheaval of internment and instead turned to contract gardening. With the exception of a lawn mower and a truck, there was little need for a large amount of capital to enter the business. The San Diego Japanese Gardener's Association sponsored this *c.* 1960 exhibit.

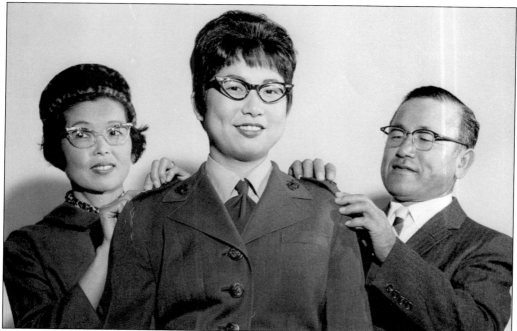

During the domestic turmoil of the 1960s, Nisei continued to serve in the armed forces. Alice Kurashige (center) and her parents, Akira and Kyomi, participated in this 1965 commissioning ceremony. Kurashige was the first female marine officer of Japanese descent from San Diego.

Nine

CREATING A NIKKEI LEGACY

At the start of the 21st century, Japanese cultural traditions, including *mochitsuki* and New Year's celebrations, continue to define the Nikkei experience. Religious establishments are also important facets of the Nikkei experience. The Japanese Christian Church (formerly the Holiness Church), the Pioneer Ocean View United Church of Christ (formerly the First Japanese Congregational Church), and the Buddhist Temple of San Diego are solid fixtures in the community. On any given day, a Nikkei group is holding a community bazaar, Bible study, bingo night, chicken dinner, senior luncheon, community meeting, or other type of activity.

National politics touched San Diego Nikkei in the 1970s and 1980s. Influenced by both the civil rights movement and student activism across the country, *Sansei* (third generation) leaders created community-based organizations to address the social problems of the 1970s. In other political arenas, San Diegans Masaaki Hironaka, Karen Sugiyama Himaka, Harry Kawamoto, and Judith Sugiyama Nakano testified at the Commission on Wartime Relocation and Internment of Civilians held in Los Angeles in the 1980s. JACL leaders like Marleen Kawahara were part of the national Redress Movement that finally obtained a U.S. government apology and a reparation check for $20,000 paid to every person still living who was evacuated.

Former detainees themselves began to come together to make sense of what happened during World War II and to reconnect with long-lost friends. Parker Valley High School alumni organized the first Poston III reunion in 1975. Coming from across California and far-flung places throughout the United States, former detainees of Poston III gathered every couple of years to renew friendships and share life milestones.

The Japanese American Historical Society of San Diego grew out of the organizing committee for the San Diego Poston III reunion of 1991. Reaching their twilight years, older Nisei wanted to preserve the history of Japanese Americans in San Diego. Sansei and Yonsei community members have joined this effort. As one JAHSSD Sansei member, Mark Abe, writes, "Learning about the people who went before us gives us insight into who we are because it is all part of where we come from."

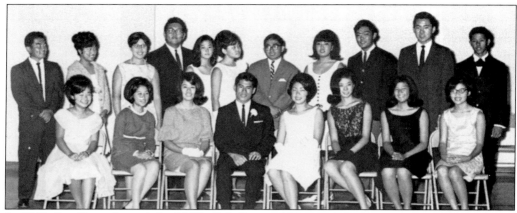

In 1966, San Diego hosted the JACL 19th Biennial National Convention. Junior JACL board members are, from left to right, (first row) Naomi Matsumoto, Ruby Uyeji, Donna Kowase, Martin Koba, Donna Hashiguchi, Jean Tani, Karen Tani, and Joyce Owashi; (second row) Akira Takeshita (youth advisor), Connie Yamaguchi, Virginia Owashi, Kiichi Hayashi, Becky Urata, Karen Sugiyama, David Takashima, Carrie Furuya, David Uda, Emory Hoshi, and Joe Yoshioka Jr.

The 1966 JACL queen Kay Ochi (left) and House of Japan queen Dorothy Wada (right) pose in front of the newly opened House of Japan. Located in Balboa Park's House of Pacific Relations, the cottage was modeled after a ceremonial Japanese teahouse.

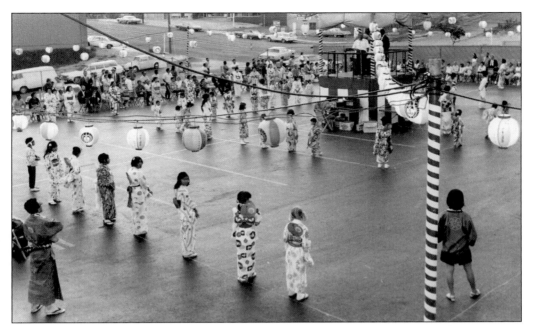

Every summer, the Buddhist Temple of San Diego sponsors an Obon festival, a celebration to pay respects to ancestors and deceased relatives. Dressed in summer kimonos, or *yukata*, participants dance in choreographed unison around the center stage in 1969. Festival attendees eat typical Nikkei foods like spam *musubi* (rice balls), chow mein, and shaved ice when resting between dances.

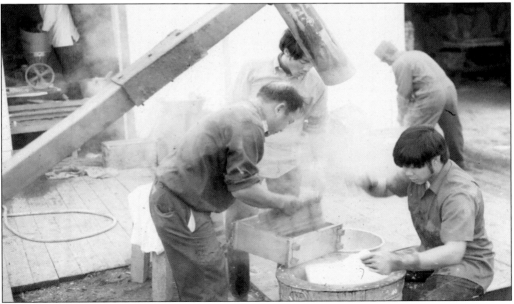

In the early 1970s, Sansei activists, influenced by the civil rights movement, formed the United Asian American Communities, an organization focused on preventing drug abuse. Their *mochitsuki* fund-raiser produced more than 1,000 pounds of *mochi* at the Ito ranch in Encanto. Trying to improve on traditional hand-held mallets, B. Matsushita and Lloyd Ito built a unique foot-powered pounder. Volunteers are, from left to right, B. Matsushita, George Ito, and Mike Ito.

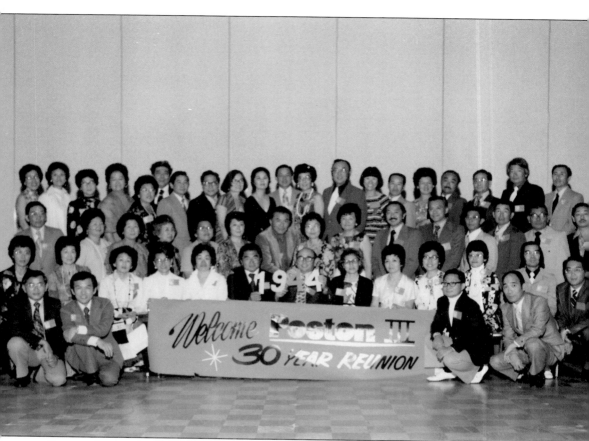

Scattered across the United States for more than 30 years, classmates from the Poston III internment camp decided to hold a reunion in 1975. What started as a high school reunion for classes graduating from 1943 to 1946 turned into a Poston Camp III reunion. The Parker Valley High School class of 1944 posed for this commemorative photograph. Poston Camp III reunions continued to be a regular event into the 21st century.

The San Diego–Yokohama Sister City Society, part of a larger movement in the 1950s to promote overseas cultural exchange and friendship, resurrected the concept of a Balboa Park Japanese Tea House in the 1970s. After years of planning and fund-raising, the Balboa Park Japanese Friendship Garden finally opened its doors in the 1990s. Many Nisei community leaders were part of the organizing committee and board of directors.

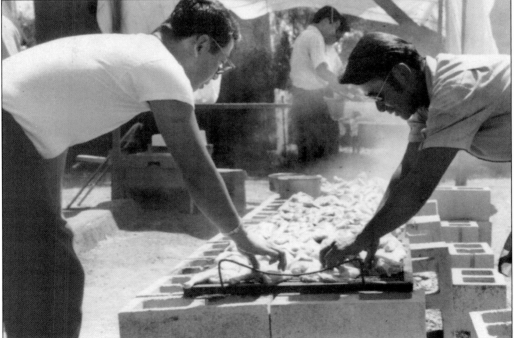

Annual bazaars and community celebrations are still popular in the Nikkei community. Roy Arakawa (left) and Harry Kowase (right) barbecue chicken at the annual Pioneer Ocean View United Church of Christ bazaar in the 1980s.

Military service created strong bonds among many Nisei men. Returning to San Diego, they found jobs, started families, and remained in contact with other veterans. Minoru "Min" Sakamoto and Tom Uda (fifth from left, back) initiated a series of meetings, and Nisei veterans chartered the Japanese American Memorial Post 4851, Veterans of Foreign Wars (VFW), in 1967 with 86 founding members.

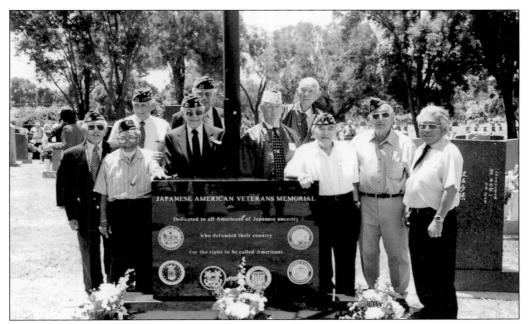

In honor of Nikkei military service, the community dedicated the Japanese American Veterans Memorial in Mount Hope Cemetery in 2006. VFW members are, from left to right, (first row) Lloyd Ito, Fredrick Fontana, Robert Buzzard, Jim Matsumoto, Oscar Kodama, and Roy Muraoka; (second row) James Yamate, Louis Gutzman, Gene Davies, and Kottie Uyeji.

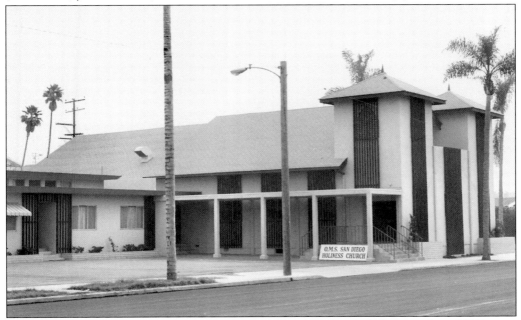

The Japanese Christian Church eventually moved to the corner of Nineteenth and E Streets. Bilingual pastors held services in both Japanese and English, and attracted numerous *Shin Issei* (post-1965 Japanese immigrants). The church (pictured here in 1985) also hosted a senior nutrition program, providing weekly meals for seniors in the community.

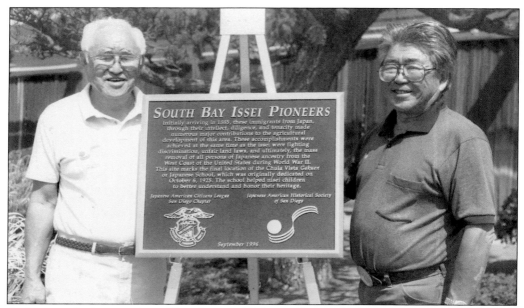

A plaque at the intersection of Broadway and Palomar Streets marks the site of the former Chula Vista *gakuen*. Ben Segawa (left) and Roy Muraoka (right) hold the commemorative plaque in 1996 before its installation. As a youngster, Roy Muraoka walked five miles to attend Japanese-language school. After the war, the Japanese-language school did not resume. The property was leased out and eventually sold in 1994.

Since 1958, the San Diego JACL has sponsored scholarships for graduating Nikkei high school students. Longtime JACL board member Masaaki Hironaka (far left) presents Christine Yoshioka of Patrick Henry High School with a scholarship certificate in the presence of her proud parents, Shinobu and Vernon Yoshioka, in 1985. Proceeds from the sale of the Chula Vista *gakuen* continue to fund JACL scholarships.

Taking care of elderly Issei and older Nisei became a priority as the Nikkei community matured. In the late 1970s, Japanese American community leaders recognized the need for affordable housing for Nikkei senior citizens. After several years of fund-raising, planning, and building, Kiku Gardens, located in Chula Vista, opened in 1983.

In the dedication ceremony, community leader Motoharu Asakawa said, "The dream of the Japanese American community of San Diego has come to realization. Kiku Gardens Senior Citizens Housing Project is a solid accomplishment belonging to the Nikkei community now and for our posterity." Volunteers, from left to right, Tomiko Funaki, Ikuko Daniels, and John Cygan prepared nutritious meals every week for South Bay senior citizens.

Retired librarian Clara Breed (far right) was a guest of honor at the 1991 Poston III reunion held in San Diego. Katherine Tasaki Segawa (left) and Louise Ogawa (center) wrote Breed numerous letters during their three-and-a-half-year exile at Poston. Reunion organizers vowed to create an organization to preserve the Nikkei experience in San Diego. The result was the Japanese American Historical Society of San Diego, formed in 1992.

The Poston monument, dedicated in 1992, brought nearly 2,000 former internees and their families back to the Arizona desert. Poston internees from Sacramento spearheaded the project, with approval from the Colorado River Indian Tribes (CRIT). Many former internees spent several weekends at the site building the monument.

Since the 1980s, different community members have participated in *Taiko* (traditional Japanese drumming). Community-based Taiko groups and a local college troupe regularly perform at local celebrations. San Diego Taiko, a multicultural group who shares a love of Japanese culture and music, performed at the eighth annual San Diego Multicultural Festival in 2006. (Courtesy of San Diego Taiko.)

Don Estes (left) and Ben Segawa (right) were founding members of the JAHSSD. A professor of history and political science at San Diego City College, Estes conducted pioneering research with Issei and wrote numerous articles and books on the Nikkei community. Annually, the JAHSSD creates numerous public exhibits and educational programs, and maintains a speaker's bureau in San Diego County.

DISCOVER THOUSANDS OF LOCAL HISTORY BOOKS FEATURING MILLIONS OF VINTAGE IMAGES

Arcadia Publishing, the leading local history publisher in the United States, is committed to making history accessible and meaningful through publishing books that celebrate and preserve the heritage of America's people and places.

Find more books like this at
www.arcadiapublishing.com

Search for your hometown history, your old stomping grounds, and even your favorite sports team.